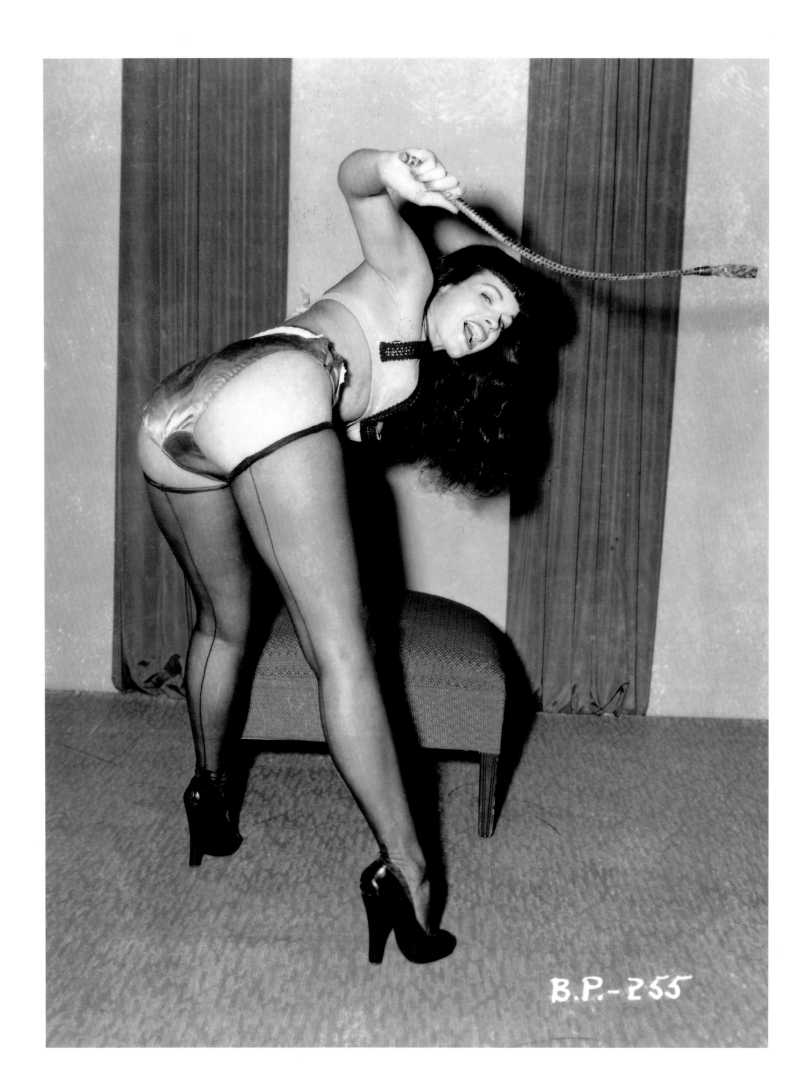

B.P.-255

Betty Page

QUEEN OF PIN-UP

Benedikt Taschen

FRONT COVER/UMSCHLAGVORDERSEITE/
PREMIERE PAGE DE COUVERTURE:
Photo: Bunny Yeager, 1955–57
© 1987 Eric Kroll collection

BACK COVER/UMSCHLAGRÜCKSEITE/
DOS DE COUVERTURE:
Photo: Irving Klaw, 1953–56
© Movie Stars News, New York

© 1993 Benedikt Taschen Verlag GmbH
Hohenzollernring 53, D-50672 Köln
All of the black-and white-photographs and, unless
otherwise indicated, the colour photographs were
taken by Irving Klaw between 1953 and 1956,
© Movie Star News, New York.
Alle Schwarzweiß-Fotos und die nicht gekenn-
zeichneten farbigen Fotos wurden zwischen
1953–1956 von Irving Klaw aufgenommen,
© Movie Star News, New York.
Toutes les photos en noir et blanc et les photos en
couleur sans référence ont été prises par Irving
Klaw entre 1953 et 1956, © Movie Star News,
New York.
All photos by Bunny Yeager © 1987 Eric Kroll
collection
Alle Fotos Bunny Yeager © 1987 aus der
Sammlung Eric Kroll
Toutes les photos de Bunny Yeager © 1987 de la
collection Eric Kroll
Edited and designed by Burkhard Riemschneider,
Cologne
Text: Harald Hellmann, Burkhard Riemschneider,
Cologne
English translation: John Smith, Cologne
French translation: Michèle Schreyer, Cologne
Typesetting: Utesch Satztechnik GmbH
Reproductions: ReproColor, Bocholt
Printed in Germany
ISBN 3-8228-9425-7

Betty Page

What she wanted to be first of all was a singer with a big orchestra. Then, like countless girls her age, she wanted to be a Hollywood star. And then, for years and years, she mulishly aimed at a career on Broadway. There may be Good Fairies who would make all three wishes come true, and God in His wisdom may sometimes grant one, but real life mostly fulfils none of them. At least Betty Page ended up not too far from her third goal – just a couple of blocks, to be exact: her New York apartment was only a short walk from Broadway. And she did become a star, even if her dreams never came true.

Legend has it that Betty made her Manhattan appearance out of nowhere, fresh from the farm, probably wearing jeans and a checked shirt and with straw in her hair – and next day found herself a pin-up superstar. It's an endearing story. But the fact of the matter is that she came from Nashville, Tennessee, a distinctly urban place to grow up in. When she arrived in New York she was by no means a naïve girl still wet behind the ears. A broken marriage already lay behind her, as well as her first fruitless attempts to gain a foothold in showbiz and a brief spell as a high-school teacher.

Betty's real name was Bettie Mae. She

Betty Page

Ihr erster Berufswunsch war, Sängerin in einem großen Orchester zu werden, dann wollte sie wie Legionen gleichaltriger Mädchen zum Film nach Hollywood, und schließlich strebte sie hartnäckig und über Jahre hinweg eine Karriere am Broadway an. Eine gute Fee läßt vielleicht drei Wünsche wahr werden, der liebe Gott möglicherweise den einen oder anderen, das wirkliche Leben erfüllt in der Regel keinen. Ihrem dritten Ziel kam Betty Page zumindest auf zwei Häuserblocks nahe: Von ihrer New Yorker Wohnung waren es nur ein paar Schritte zum Broadway. Ihre Träume erfüllten sich nicht, ein Star wurde sie dennoch.

Einer beliebten Legende zufolge erschien Betty eines Tages frisch von der Farm – wahrscheinlich mit Jeans, kariertem Hemd und Stroh im Haar – in Manhattan und war am nächsten Tag ein Pin-up-Superstar. Eine schöne Geschichte für Bildunterschriften. Tatsächlich stammt sie aus Nashville, Tennessee, einem recht urbanen Rahmen also, und war keineswegs ein naives, unbedarftes Mädchen, als sie in New York eintraf. Hinter ihr lagen eine gescheiterte Ehe, die ersten fruchtlosen Versuche, im Showbiz Fuß zu fassen, und ein Kurzauftritt als High-School-Lehrerin.

Betty, eigentlich Bettie Mae, wurde am 22. April 1923 in Downtown-Nashville geboren. Bereits in der High-School entwickelte sie ein Faible für die Bühne, ihr Engagement beschränkte sich allerdings nicht nur auf die Mitarbeit in der Theatergruppe, denn Betty nahm an fast allen Aktivitäten teil, mit denen man an der High-School Pluspunkte sammeln kann, und schloß die Schule als Musterschülerin ab. Fragte man sie nach ihrem Traumberuf, so wünschte sie sich, Sängerin in einem großen Orchester zu werden. Mit einem Stipendium der »Daughters of the American Revolution« besuchte sie von 1940 bis 1944 das Peabody College und versuchte sich anschließend – so heißt es – als Englischlehrerin. Dies kann nur ein Intermezzo gewesen sein,

Betty Page

Elle voulait devenir chanteuse dans un grand orchestre; ensuite, comme tant d'autres jeunes filles, elle rêva des studios de Hollywood, et pour finir, elle essaya pendant des années avec obstination de faire carrière à Broadway. Géographiquement, d'ailleurs, Betty Page n'en était pas loin: son appartement de New York se trouvait à deux pas de Broadway. Mais la bonne fée n'était pas au rendez-vous et aucun de ses vœux ne fut exaucé.

La légende veut que Betty soit arrivée un jour à Manhattan, sortie tout droit de sa ferme, probablement en jeans, chemisette à carreaux, sans oublier les fétus de paille dans les cheveux, et ait été couronnée superstar le lendemain. Une histoire charmante, mais éloignée de la vérité. En fait, elle est originaire de Nashville, la capitale du Tennessee, et n'était certainement plus une oie blanche en arrivant à New York. Elle avait à son actif un mariage raté, quelques tentatives infructueuses pour s'établir dans le showbiz et un bref intermède en tant qu'enseignante.

Betty Mae naît le 22 avril 1923 à Downtown-Nashville. Elle fait du théâtre à l'école secondaire, mais participe aussi à presque toutes les activités qu'offre l'école pour rassembler des points, se faisant ainsi une réputation d'élève modèle. Si on lui demande quels sont ses projets, elle répond qu'elle veut devenir chanteuse dans un grand orchestre. Dotée d'une bourse des «Daughters of the American Revolution», elle fréquente de 1940 à 1944 le Peabody College et essaie ensuite, d'après ce que l'on dit, de devenir professeur d'anglais. Cela ne peut avoir duré très longtemps, puisqu'elle tente la même année d'obtenir un contrat dans une des grandes sociétés cinématographiques de Hollywood. Ensuite, on sait bien peu de choses, sinon qu'elle s'installe avec sa sœur à San Francisco, fait la connaissance de Bill qu'elle épouse et accompagne à Pittsburgh avant de divorcer.

En 1948, Betty arrive à New York avec dans la tête l'idée bien arrêtée de faire

was born on 22 April 1923 in downtown Nashville. At high school her love of the stage and her ability to enter wholeheartedly into what she was doing went far beyond high-school theatre. She did practically everything that could earn her bonuses and credits. And she left school a model pupil. When asked what she wanted to become, she'd say she would like to be a singer with a big orchestra. Next she went to Peabody College, from 1940 to 1944, on a »Daughters of the American Revolution« scholarship. When she had finished her studies, she supposedly tried her hand as an English teacher, but it can have been only a short intermezzo, since in that same year of 1944 she tried to land a contract with one of the big movie companies. In vain. Little is known of that episode, or of the years that followed, during which she apparently moved to San Francisco with her sister, met a man called Bill and married him, moved to Pittsburgh, and separated there, the marriage proving ill-starred.

In 1948 Betty went to New York. She wanted to make it on Broadway, and throughout her New York years she never gave up that aim. But the acting courses she took cost money, and soon Betty was working as a model for various »camera clubs«. For a fee, the clubs would provide amateur photographers with models, studio facilities and expert advice. Models found them an attractive source of supplementary income, while the photographers particularly relished the club photo-safaris in the country, when as many as sixty photographers at a time would have the chance to shoot their favourite models in the open air. These glamour shoots were not easy to keep quiet, and from time to time the clubs brushed with the provincial law. On one of these Sunday outings in the '50s, organized by '40s bandleader Cass Carr from Jamaica (who had founded the »Concord Camera Circle«), Betty was on the verge of being arrested along with the entire troupe of fans. One of those fined for causing a public nuisance was the legendary Weegee.

Betty made her entry into the world of

denn im selben Jahr, 1944, bemüht sie sich in Hollywood vergebens um einen Vertrag bei einer der großen Filmgesellschaften. Eine Episode, über die ebensowenig bekannt ist wie über die Folgejahre: Sie zieht mit ihrer Schwester nach San Franzisko, lernt einen gewissen Bill kennen, man heiratet, anscheinend unter einem ungünstigen Stern, geht gemeinsam nach Pittsburgh und trennt sich wieder.

1948 kommt Betty nach New York. Sie will an den Broadway, ein Ziel, das sie während ihrer gesamten New Yorker Zeit nicht aufgeben wird. Die diversen Schauspielschulen, an denen sie Kurse belegt, kosten Geld, und bald arbeitet Betty als Model für verschiedene »Camera Clubs«. »Camera Clubs« stellten Fotografen und Fotoenthusiasten gegen Entgelt Models, Studios und fachkundigen Rat zur Verfügung und waren eine beliebte zusätzliche Einkommensquelle für die Fotomodelle. Großer Beliebtheit erfreuten sich die Fotosafaris der »Camera Clubs« ins Umland, bei denen bis zu 60 Fotografen die Gelegenheit bekamen, ihre Lieblingsmodels unter freiem Himmel abzulichten. Aktionen, die sich kaum verbergen ließen und gelegentlich zum Konflikt mit der Provinzjustiz führten. Bei einem dieser Sonntagsausflüge in den fünfziger Jahren, arrangiert von Cass Carr, einem jamaikanischen Bandleader der vierziger Jahre, der den »Concord Camera Circle« gegründet hatte, sollte Betty mitsamt ihrer Fangemeinde festgenommen werden. Unter jenen, die wegen Ruhestörung und Erregung öffentlichen Ärgernisses zur Kasse gebeten wurden, fand sich auch der legendäre Weegee.

Ihren Einstand in der Welt des Pin-up gab Betty aber in den Magazinen des Robert Harrison, dem König der »Girlie Magazines«. Harrison hatte bereits während des Zweiten Weltkriegs den Markt mit halbnackten Tatsachen entdeckt und mit bescheidenem Anfangskapital sein erstes Objekt, »Beauty Parade«, produziert. Wer sich nicht unter der Ladentheke bedienen wollte und an Nudistenmagazinen keinen rechten Spaß fand, konnte in den folgenden Jahren auf Harrison bauen, der den

carrière à Broadway. Mais la vie est dure, les cours d'art dramatique coûtent cher, et elle va bientôt travailler comme modèle pour divers «Camera Clubs». Les «Camera Clubs» mettaient des mannequins, des studios et leur expérience au service des photographes et des passionnés de la photo. Pour les modèles ils représentaient un «à côté» appréciable. Les safaris-photos des «Camera Clubs» étaient très recherchés: jusqu'à 60 photographes avaient alors l'occasion de photographier leurs mannequins préférés dans la nature. Un genre d'activités impossible à dissimuler, ce qui engendrait parfois des conflits avec la justice provinciale. Au cours d'une excursion organisée par Cass Carr, un bandleader jamaïcain des années quarante qui avait fondé le «Concord Camera Circle», Betty est arrêtée avec ses admirateurs. Le légendaire Weegee était l'un de ceux qui durent payer une amende pour avoir troublé la tranquillité publique.

C'est dans les magazines de Robert Harrison, le roi des «Girlie Magazines», que Betty fait son entrée dans le monde des pin up. Harrison avait découvert ce créneau pendant la Seconde Guerre mondiale et produit son premier illustré «Beauty Parade» avec un capital de départ fort modeste. Harrison fut accueilli comme un bienfaiteur par ceux qui ne voulaient pas des magazines de «derrière le comptoir» et n'appréciaient pas les magazines nudistes: dans les années qui suivirent, il inonda le marché avec d'innombrables fascicules tels que «Eyeful», «Wink» ou «Titter». En couverture une pin-up accrocheuse, à l'intérieur des filles en tenue légère dans des situations comiques ou grotesques. Betty va, elle aussi, faire des grimaces, écarquiller les yeux et porter de drôles de petits chapeaux. Si elle n'avait fait que cela, plus personne ne se souviendrait d'elle aujourd'hui, mais elle rencontre fin 1951 Irving et Paula Klaw qui vont faire d'elle une vedette.

L'ascension des Klaw a commencé à la fin des années trente à Manhattan, dans une librairie située au 209 East 14th Street. Irving Klaw et sa sœur

the pin-ups in the magazines of Robert Harrison, king of the »girlie magazines«. Harrison had discovered the market for the bare (or at least scantily clad) facts in the Second World War. With modest starting capital he had produced »Beauty Parade«, his first publication. Those who didn't want the under-the-counter products and didn't care for nudist magazines could always rely on Harrison titles such as »Eyeful«, »Wink« or »Titter«. The cover was always a sizzling pin-up, and inside there would be photo features of girls not exactly overdressed, in comic or grotesque situations – a kind of naughty burlesque. Betty appeared pulling faces, wide-eyed and wearing silly bonnets like the rest. If she had never done any other kind of modelling work she would now be long forgotten. Betty Page the star, Betty Page the legend, was created by two people, brother and sister, whom she met in late 1951: Irving and Paula Klaw.

The Klaws' career had begun in the late '30s in a secondhand book store at 209 East 14th Street in Manhattan. They quickly realised that pictures of film stars earned better money than dog-eared books and magazines, and they set out to satisfy the demand. Irving placed advertisements in movie magazines, and soon the orders were flooding in from all over the world. Business boomed. They moved to bigger premises, and published their own regular mail–order catalogue, »Movie Star News«, as well as the twice-yearly »Cartoon and Model Parade«. The Klaws would supply whatever the customers demanded. But presently it emerged that a sizeable proportion of the clientèle had a lively interest in bondage photos and spanking. It was a demand the Klaws couldn't satisfy through their Hollywood connections. The story goes that one of these customers, known as »Little John«, suggested shooting the photos himself. It soon proved the perfect idea, and the Klaws became specialists in fetishist material. There was no shortage of models in New York, and production costs were low. Once Paula (who was in charge of production) had watched

Markt mit zahllosen Heften wie »Eyeful«, »Wink« oder »Titter« überschwemmte. Auf den Covern knallige Pin-up-Illustrationen, im Heft Fotofeatures mit dürftig bekleideten Mädchen in komischen oder grotesken Situationen, burleske Nummernrevuen. Auch Betty muß Grimassen schneiden, die Augen aufreißen und lustige Hütchen tragen. Hätte sich ihre Tätigkeit als Model auf Aufträge dieser Art beschränkt, würde sich heute niemand mehr an sie erinnern. Zum Star und zur Legende wurde sie erst durch ein Geschwisterpaar, dem sie Ende 1951 vorgestellt wurde: Irving und Paula Klaw. Die Karriere der Klaws begann Ende der dreißiger Jahre in einem Antiquariat in der 209 East 14th Street in Manhattan. Sie registrierten schnell, daß sich mit Aufnahmen beliebter Filmstars wesentlich schneller Geld verdienen ließ als mit gebrauchten Büchern und Magazinen, und richteten sich auf diese Nachfrage ein. Irving schaltete Anzeigen in diversen Filmmagazinen und erhielt Bestellungen aus aller Welt. Das Geschäft expandierte, man zog in größere Räume, und gab regelmäßig einen Mailorder-Katalog, die »Movie Star News«, und alle sechs Monate die »Cartoon and Model Parade« heraus. Die Klaws organisierten, was immer die Kundschaft wollte, allein es stellte sich heraus, daß ein nicht kleiner Teil der Kundschaft ein ausgeprägtes Interesse an Fotos gefesselter Schönheiten und an »Spanking«-Material hegte. Eine Nachfrage, die die Klaws nicht über ihre Beziehungen in Hollywood befriedigen konnten. Der Legende nach schlug einer dieser speziellen Kunden, der unter dem Namen »Little John« bekannt war, vor, die gewünschten Aufnahmen doch einfach selbst zu produzieren. Eine großartige Idee, wie sich schnell herausstellte. Die Klaws wurden die Spezialisten für Fetisch-Material. Models gab es in New York zur Genüge, die Produktionskosten waren gering, und nachdem Paula, die die Aufnahmen leitete, den Fotografen eine Weile bei der Arbeit zugesehen hatte, nahm sie selbst den Platz hinter der Kamera ein. Neben Fotografien boten sie Kurzfilme

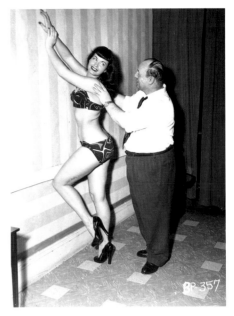

Betty and Irving Klaw, New York, 1951–56
Betty und Irving Klaw, New York, 1951–56
Betty et Irving Klaw, New York, 1951–56

Paula remarquèrent vite que les photos de vedettes populaires rapportaient plus que les livres d'occasion et les magazines. Ils agirent en conséquence et annoncèrent dans divers magazines de cinéma. Les commandes du monde entier affluèrent. Les affaires prospéraient, on emménagea dans des bureaux plus vastes. Un catalogue de vente par correspondance, le «Movie Star News» paraissait chaque mois et le «Cartoon and Model Parade» tous les six mois. Les Klaw organisaient ce que la clientèle désirait, et il apparut que certains clients éprouvaient un intérêt marqué pour les photos de belles enchaînées et la panoplie sadomasochiste. Une demande que les Klaw ne pouvaient pas encore satisfaire. Un de ces clients, connu sous le nom de «Little John», aurait alors proposé aux Klaw de produire ces photos eux-mêmes. Cela s'avéra être une idée géniale. Les Klaw devinrent les spécialistes du matériel fétichiste. La ville regorgeait de mannequins, les frais de production étaient bas, et Paula se mit à prendre les photos elle-même, après avoir observé pendant un certain temps les photographes professionnels. Les Klaw offraient maintenant des photographies, des courts métrages et des dessins animés sado-masochistes. Stanton par exemple, dont les dessins valent des sommes astrono-

the photographers at work for a while, she took to taking the pictures herself. As well as photographs, the Klaws supplied short films and bondage comics. Stanton, whose drawings now fetch astronomical sums, started out in the expanding Klaw empire.

In 1952 Betty Page made her first appearance on the cover of »Cartoon and Model Parade«. That year's catalogue did not feature her, but by the following year she had already become the Klaws' top model. Betty would be shown dancing, tied up or with a whip, but always wearing high heels and most of the time a smile – a smile that was neither lewd nor coarse and must surely have contributed greatly to her success. Though she was now 30, she was »something special«. She still had the looks of a trim, pert teenager fresh from the cover of a thriller. She had a fresh, earthy image quite unlike that of other models, and a mischievous way of conveying that she'd seen the naughty sides of life. Plainly she saw the bondage and spanking pictures she did with the Klaws as a continuation of the clownish pin-up work she'd done for Harrison: she would still stare in wide-eyed horror and exaggerate responses for comic effect. But then, what woman could keep a straight face if she was being spanked with a hairbrush?

As well as working for the Klaws (she was notorious for turning up hours late

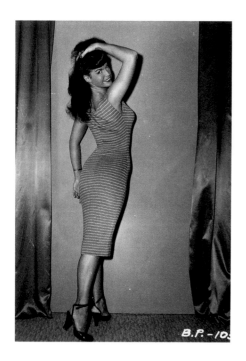

B.P.-10.

und »Bondage-Comics« an. Stanton etwa, dessen Zeichnungen heute für astronomische Summen gehandelt werden, begann seine Karriere im stetig expandierenden Imperium der Klaws.

1952 erscheint Betty Page zum erstenmal auf dem Cover der »Cartoon and Model Parade«, der Katalog selbst bietet noch kein Material von ihr an, doch schon im nächsten Jahr ist sie zu Klaws Topmodel avanciert. Betty tanzend, Betty in Fesseln, Betty mit Peitsche, immer in High Heels und meistens mit einem Lachen auf dem Gesicht, das nichts Lasziges und nichts Verworfenes hat und sicherlich nicht unwesentlich zu ihrem Erfolg beiträgt. Betty ist »something special«, obwohl mittlerweile fast 30, sieht sie immer noch wie ein kompakter, kesser Teenager aus, der gerade vom Cover eines reißerischen Halbstarken-Romans gestiegen ist. Frisch, bodenständig, den Schalk im Nacken und so ganz anders als ihre Kolleginnen, die durchaus erkennen ließen, daß sie die schmutzige Seite des Lebens nicht nur vom Hörensagen kannten. Die »Bondage«- und »Spanking«-Aufnahmen der Klaws sieht Betty offensichtlich als Fortsetzung ihrer Ulknudel-Nummern aus den Harrison-Magazinen: die Augen stets etwas zu weit aufgerissen und der Schrecken immer komisch überzeichnet. Wer kann aber auch ernst bleiben, wenn er gerade mit einer Haarbürste versohlt wird? Neben ihrer Arbeit für die Klaws, zu deren Terminen sie notorisch um Stunden zu spät kommt, ließ sie sich weiter von »Camera Clubs« engagieren (dort fielen dann auch mal alle Hüllen) und nahm mit ungemindertem Enthusiasmus Schauspielunterricht. Auf der Bühne steht sie allerdings nur in Publikumsveranstaltungen ihrer Schulen und bei wenig anspruchsvollen Sommertheater-Inszenierungen auf Long Island; der Broadway blieb unerreichbar. Immerhin kommt sie doch noch in die Kinos: Angeregt durch den Erfolg der abendfüllenden burlesken Nummernrevue »Strip-O-Rama« (1953) produziert Irving Klaw mit einer flugs gegründeten Filmgesellschaft zwei ähnliche Streifen, »Varietease« (1954)

miques aujourd'hui, commença sa carrière chez les Klaw.

En 1952, Betty apparaît pour la première fois en couverture du «Cartoon and Model Parade», on ne voit rien d'elle dans le catalogue, mais l'année suivante elle devient le top model des Klaw: Betty en train de danser, Betty enchaînée, Betty au fouet, toujours en talons hauts et arborant le plus souvent un sourire absolument dépourvu de lascivité, ce qui a certainement contribué à son succès. Betty c'est «something special»: à près de trente ans, elle garde ses allures de teenager sortie tout droit de la couverture d'un roman pour jeunes voyous. Fraîche, naturelle, toujours espiègle, donc très différente de ses collègues qui ne laissent que trop voir leur grande expérience de la vie. Betty considère manifestement les photographies sadomasochistes des Klaw comme la suite de ses numéros burlesques dans les magazines Harrison: ses yeux sont toujours trop écarquillés et son effroi teinté de comique. D'ailleurs comment garder son sérieux quand on reçoit une fessée avec une brosse à cheveux? A côté de ses rendez-vous de travail pour les Klaw où elle arrive toujours avec des heures de retard, elle continue à se faire photographier par les «Camera Clubs» (pour eux, elle laissera tomber les derniers voiles) et se rend avec un zèle non entamé à ses cours de comédie. Elle ne jouera pourtant que dans le cadre des écoles d'art dramatique et dans des mises en scène peu exigeantes du théâtre d'été à Long Island. Broadway reste hors d'atteinte. Mais on la verra au cinéma: la revue burlesque «Strip-O-Rama» (1953) a tant de succès qu'Irving Klaw produit deux films du même genre, «Varietease» (1954) et «Teaserama», avec une société cinématographique fondée à toute allure. Betty tourne dans les trois films.

Il existe pourtant une autre Betty que la belle esclave des salons tristes d'Irving Klaw. Elle a l'habitude de rendre visite à sa sœur qui habite Hollywood, et les photographes de l'endroit vont profiter de l'occasion. Betty, fille saine et sportive en bikini, est un motif de carte postale remarquable. C'est en

at shoots), Betty was still posing for the camera clubs, occasionally in the altogether. She was also still taking acting classes, her enthusiasm undiminished. But her only stage appearances were at drama-school events and undemanding Long Island summer theatre productions. Broadway remained out of reach. She did make it onto the cinema screen, though. Inspired by the success of the full-length revue »Strip-o-Rama« (1953), Irving Klaw promptly started his own film company and produced two similar movies, »Varietease« (1954) and »Teaserama« (1955). Betty made appearances in all three films.

The '50s also saw Betty from another side that was quite different from the Queen of Bondage in Klaw's sparsely-furnished back rooms. In the holidays she would visit her sister in Hollywood, and the local photographers would make good use of the opportunity. Betty the clean-living, sporty girl in a bikini was perfect for postcards. In Florida she met Bunny Yeager, an ex-model turned photographer who was just starting her new career. Bunny Yeager sent her photos of Betty to »Playboy«, and Hugh Hefner responded by making Betty the centrefold girl in the magazine's January 1955 issue. For Irving Klaw, though, who had given Betty's career its decisive turn, the year began rather less auspiciously. The police, post office and FBI had long been keeping an eye on Klaw, but once the Senate began investigating juvenile crime, trouble was heading his way, trouble that a simple call to his lawyer couldn't avert. Senator Estes Kefauver took it as read that not only comics but also the Klaws' »dirt« was responsible for the growing demand for leather jackets and flick-knives. For Klaw, it was the beginning of a tussle with the law that was to last for years. This may have contributed to Betty's decision (in 1957) to part, with thanks, from the Klaws. Her decision can hardly have improved Klaw's mood. Soon after, Betty Page dropped off the map altogether: the queen of the pin-ups had disappeared without a trace.

Harald Hellmann

und »Teaserama« (1955). Betty hat in allen drei Filmen ihren Auftritt.

Die Fünfziger bekommen aber auch noch eine andere Betty zu sehen als die »Queen of Bondage« aus Klaws spartanisch möblierten Hinterzimmern: In den Ferien pflegte sie ihre Schwester in Hollywood zu besuchen, und die ortsansässigen Fotografen lassen sich diese Gelegenheit nicht entgehen. Betty als sauberes, sportliches Bikini-Mädchen am Strand war ein hervorragendes Postkartenmotiv. In Florida lernt Betty auch Bunny Yeager kennen, ein Ex-Model, das hinter die Kamera gewechselt war und gerade am Beginn ihrer neuen Karriere steht. Bunny Yeager schickt einige Aufnahmen, die sie von Betty gemacht hat, an den »Playboy«, und Hugh Hefner greift zu: Betty wird Centerfold im Januar-Playboy 1955. Für den Mann, der Bettys Aufstieg den entscheidenden Kick gegeben hat, läuft das Jahr weniger gut an. Die örtliche Polizei, die Postbehörde und das FBI hatten Irving Klaw schon länger im Auge, doch mit den Senatsuntersuchungen zur Jugendkriminalität kommt Ärger auf ihn zu, der sich nicht durch ein Telefonat mit dem Anwalt erledigen läßt. Für Senator Kefauver ist es eine ausgemachte Sache, daß etwa neben den Comic-Heften auch »schmutziges Material« der Firma Klaw für die verstärkte Nachfrage nach Lederjacken und Springmessern verantwortlich ist. Für Klaw beginnt ein Ringen mit der Justiz, das sich über Jahre hinziehen soll. Ob dies mit dazu beigetragen hat, daß sich Betty 1957 mit bestem Dank für alles von den Klaws verabschiedet, bleibt ungeklärt. Glücklicher dürfte es Klaw nicht gemacht haben. Kurze Zeit später steigt Betty in den Zug nach Nirgendwo. Die Königin der Kurven verschwindet spurlos.

Harald Hellmann

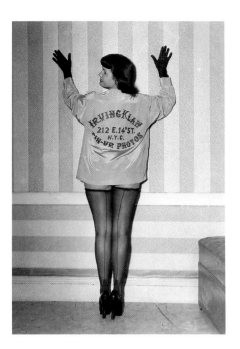

Floride que Betty fait la connaissance de Bunny Yeager, un ancien mannequin passée de l'autre côté de la caméra et qui commence sa carrière. Bunny Yeager envoie quelques photos de Betty à «Playboy» et Hugh Hefner les accepte: Betty fait le dépliant central du «Playboy» de janvier 1955. Pour Irving Klaw, par contre, l'année s'annonce mal. La police locale, la poste et le FBI l'observaient depuis longtemps, mais ses ennuis réels commencent avec l'enquête du Sénat sur la criminalité juvénile. Pour son adversaire le plus populaire, Estes Kefauver, le sénateur du Tennessee, il va de soi qu'à côté des bandes dessinées, le «matériel malpropre» de la société Klaw est responsable de la demande accrue en vestes de cuir et couteaux à crans d'arrêt. Irving Klaw a devant lui des années de procédure. On ne sait pas si c'est l'une des raisons pour lesquelles Betty se sépare des Klaw en 1957. On doute que Klaw s'en soit réjoui. Peu de temps après, Betty disparaît et on perd sa trace.

Harald Hellmann

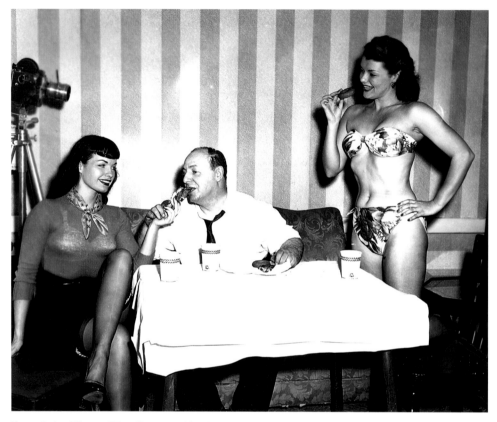

Betty, Irving Klaw and Roz Greenwood in Klaw's studio, New York, 1951–56
Betty, Irving Klaw und Roz Greenwood in Klaws Studio, New York, 1951–56
Betty, Irving Klaw et Roz Greenwood dans le studio de Klaw, New York, 1951–56

Right / rechts / à droite:
Preparation for a photo session for »Motel Room«,
New York, 1951–56 (See p. 12/13)
Vorbereitung einer Einstellung zu »Motel Room«,
New York, 1951–56 (vgl. S. 12/13)
Avant la prise de vue pour «Motel Room», New
York, 1951–56 (voir p. 12/13)

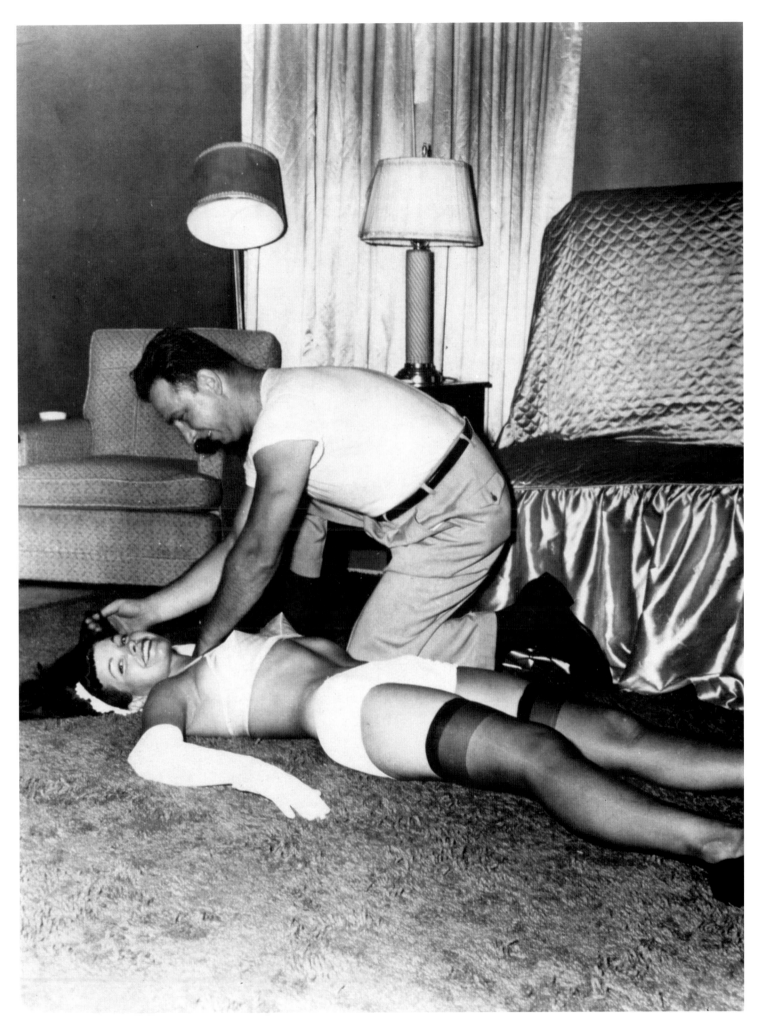

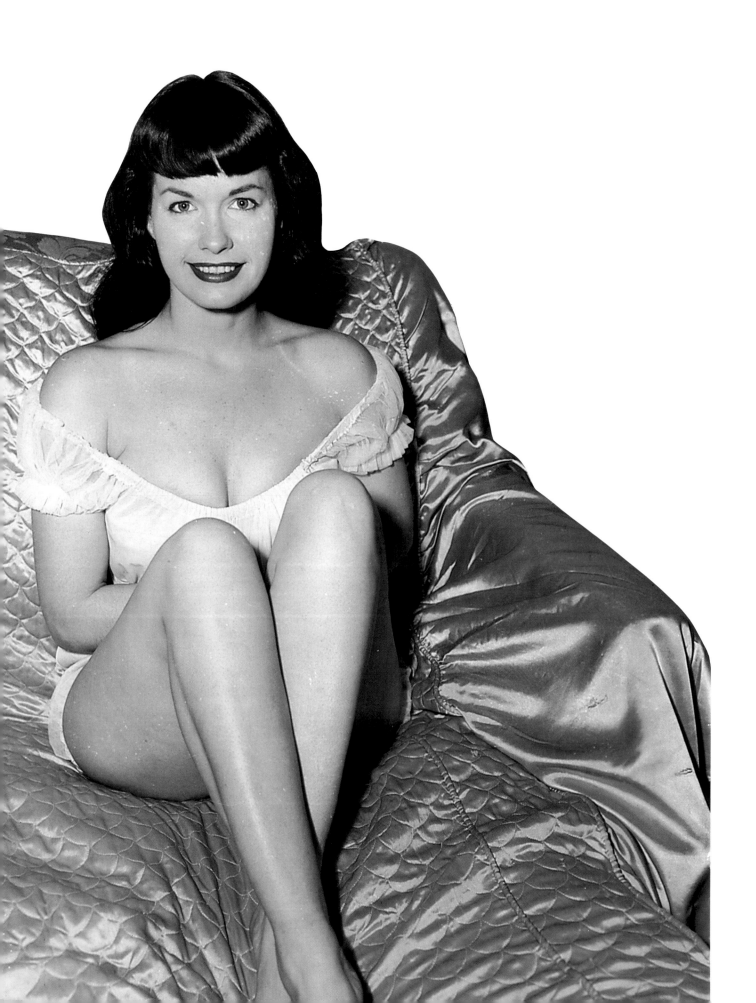

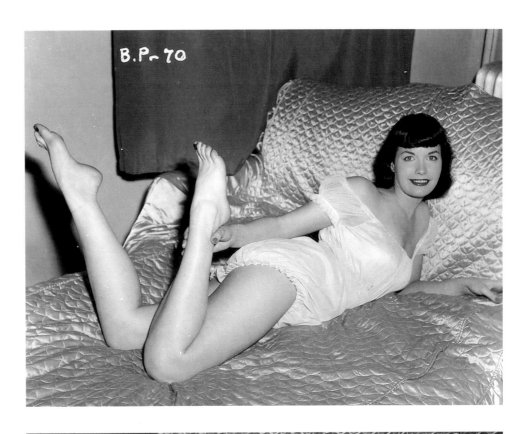

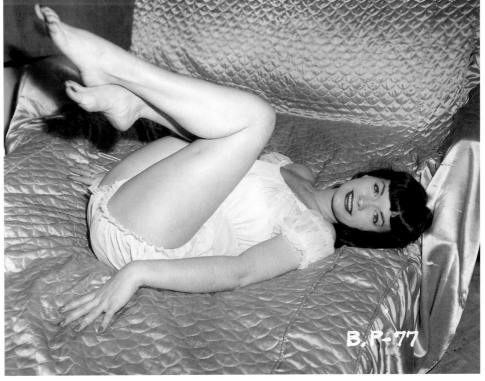

13

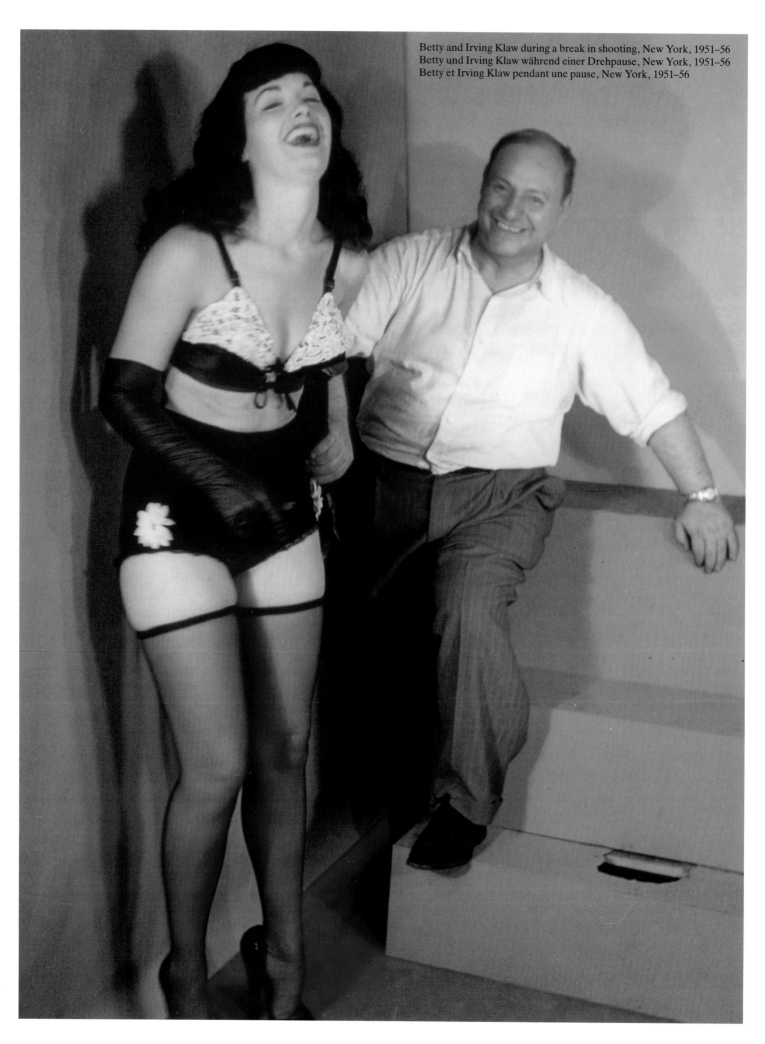

Betty and Irving Klaw during a break in shooting, New York, 1951–56
Betty und Irving Klaw während einer Drehpause, New York, 1951–56
Betty et Irving Klaw pendant une pause, New York, 1951–56

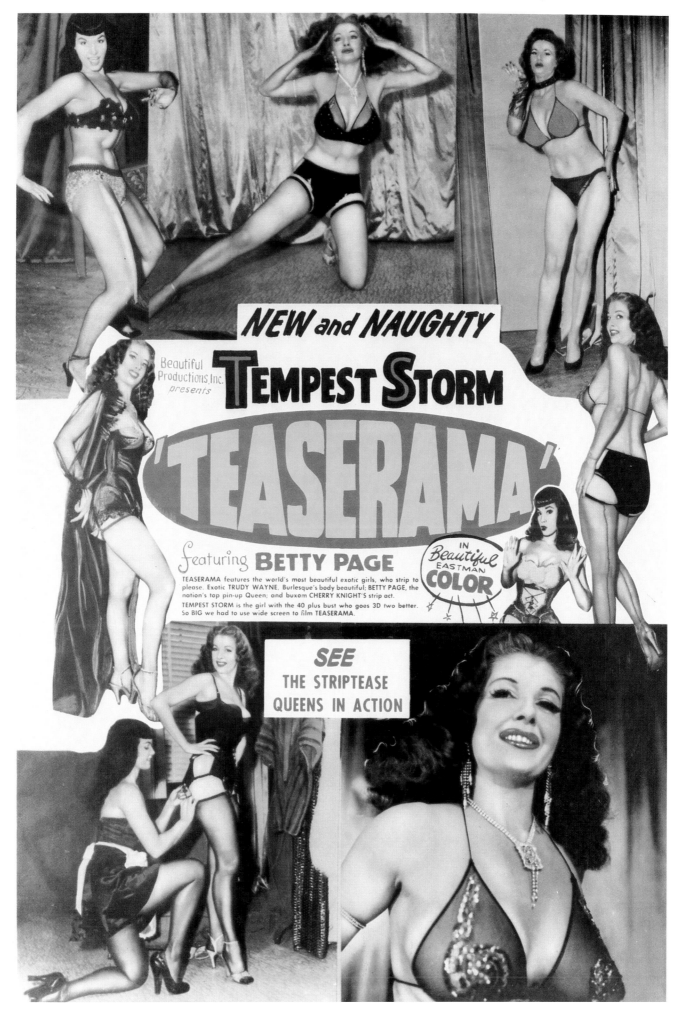

Film poster, 1955/Filmplakat, 1955/Affiche de cinéma, 1955

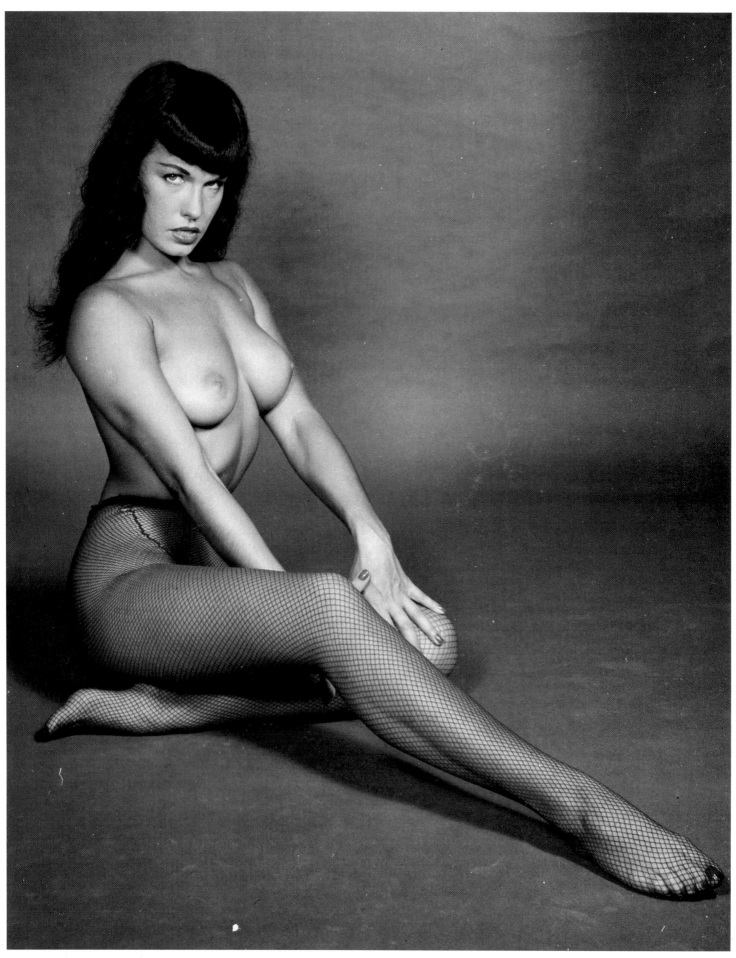

Photo: Bunny Yeager, 1955–57

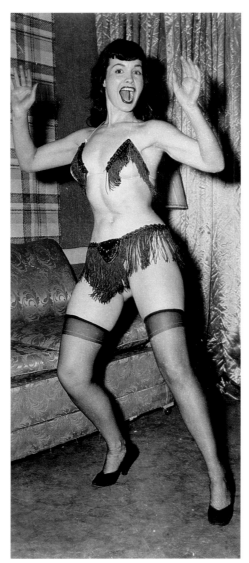

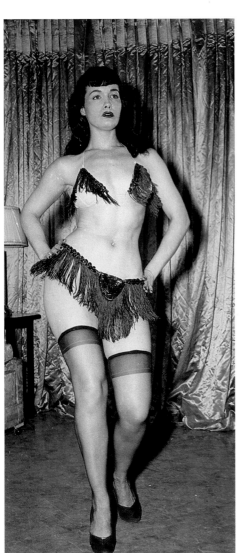

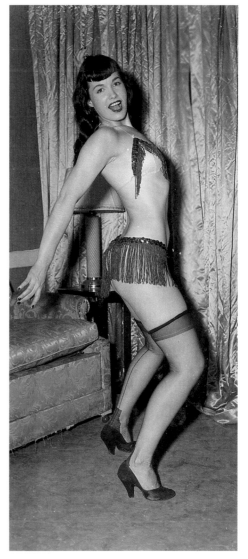

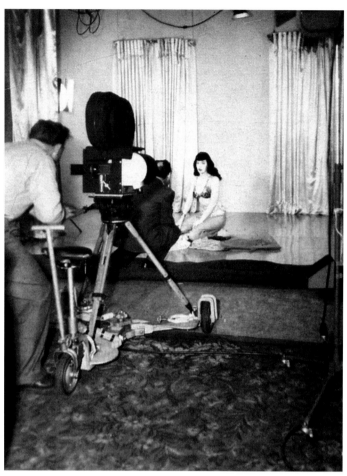

Betty receiving stage directions for the dance scenes, New York, 1951–56
Betty erhält Regieanweisungen für die Tanzszenen, New York, 1951–56
Le metteur en scène donne des instructions pour les scènes de danse, New York, 1951–56

The Dance of the Seven Veils

Betty meets the Arabian Nights. Dance routines naturally require accessories and costumes, but it's rare for Betty to adopt the out-and-out harem look. Those who want to can trace the tradition back via Claudette Colbert's »Cleopatra« (1934) and Theda Bara's »Salome« (1918) to the Orientalism of the 19th century – or even, indeed, to Ishtar's Dance of the Seven Veils in ancient Babylon. The Hollywood version, for preference.

Schleiertanz

Betty in Tausendundeiner Nacht. Tanznummern brauchen natürlich Accessoires und Kostüme, aber nur selten gibt es bei Betty etwas so Naheliegendes wie den Harems-Look. Wer will, kann dessen Tradition über Claudette Colbert als »Cleopatra« (1934) und Theda Bara als »Salome« (1918) zurück bis zur Orient-Manie des 19. Jahrhunderts verfolgen. Ganz Hartnäckige vielleicht bis nach Babylon zum »Schleiertanz der Ischtar«. In der Hollywood-Version, bitte.

La danse du voile

Betty et les Mille et Une Nuits. Des accessoires et des costumes sont nécessaires pour danser, mais on verra rarement Betty dans un harem. En fait, le 19ème siècle appréciait déjà les décors orientaux que l'on retrouve d'ailleurs dans «Salomé» (1918) avec Theda Bara et «Cléopâtre» (1934) avec Claudette Colbert. On peut même aller plus loin et remonter à Babylone et évoquer la danse d'Istar. Revue par Hollywood, cela va de soi.

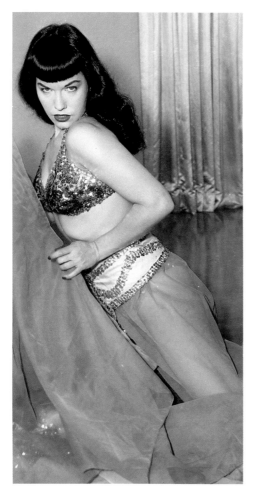 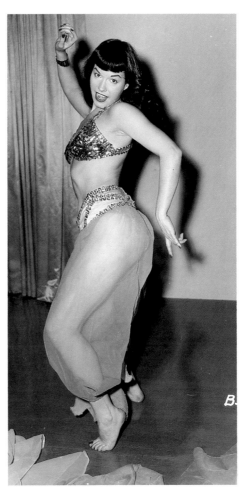

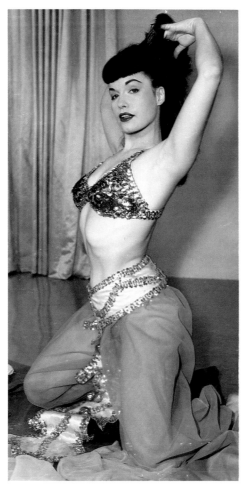 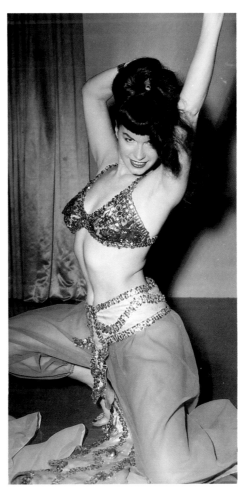

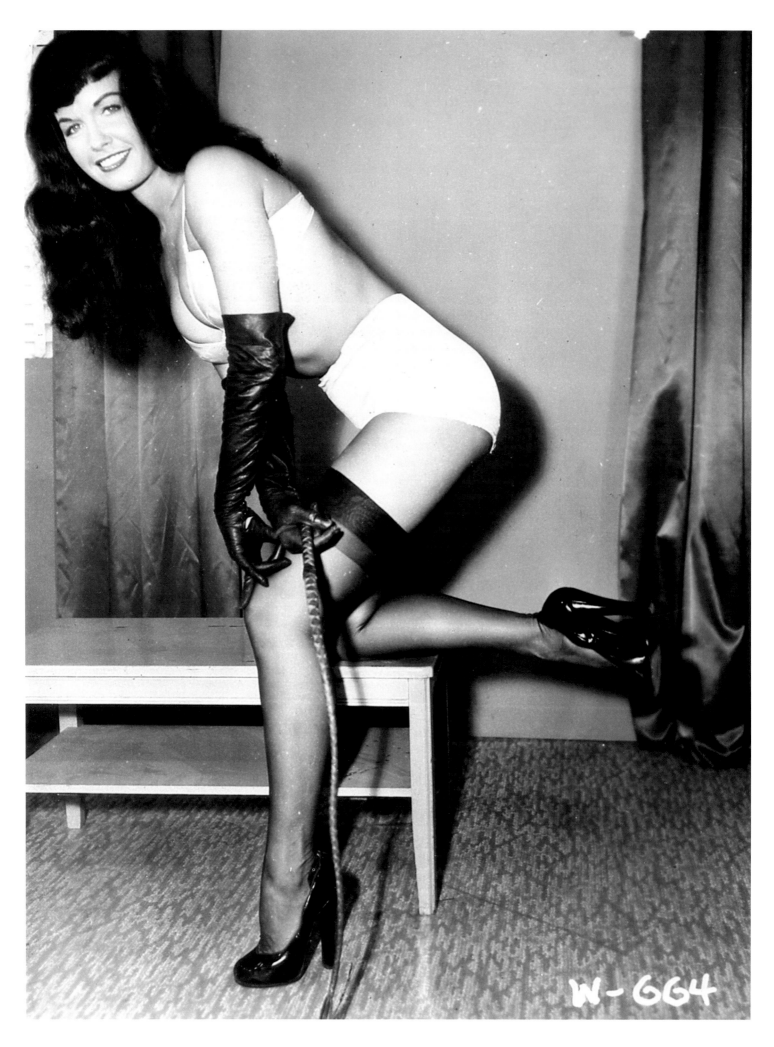

W-664

20

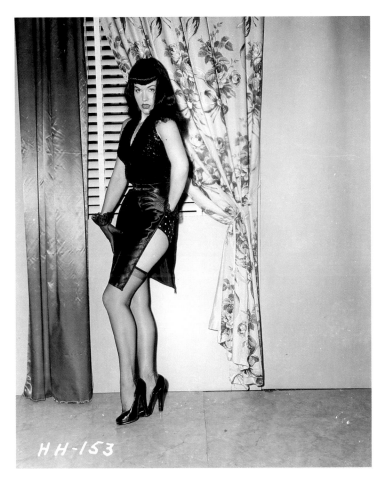

HH-153

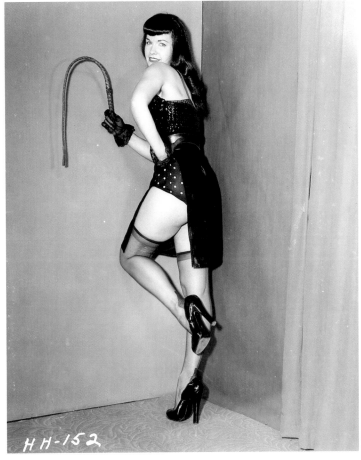

HH-152

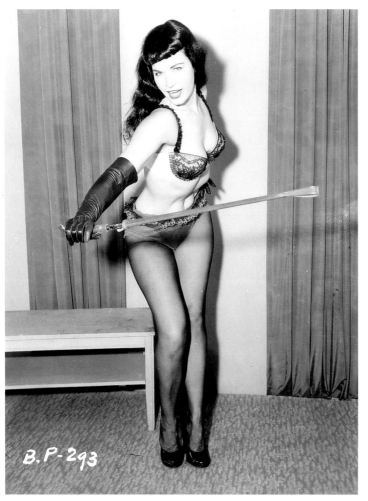

B.P.-293

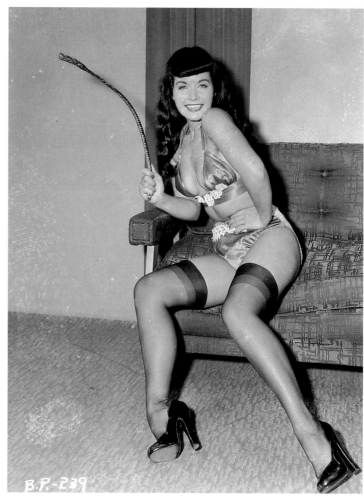

B.P.-239

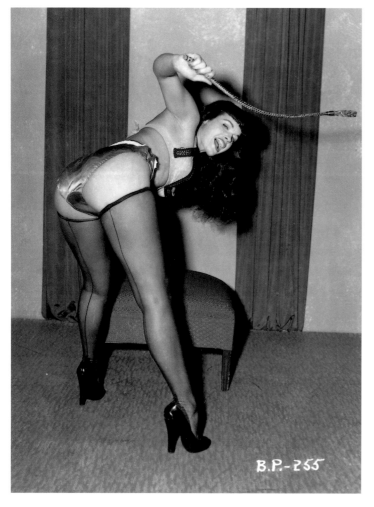

B.P.-255

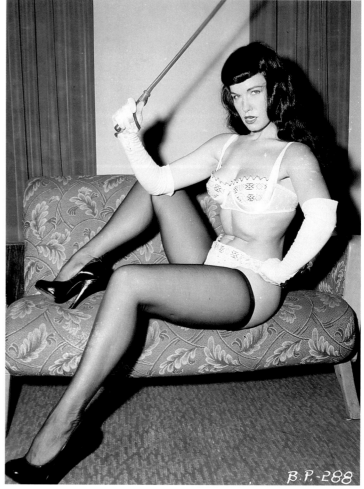

B.P.-288

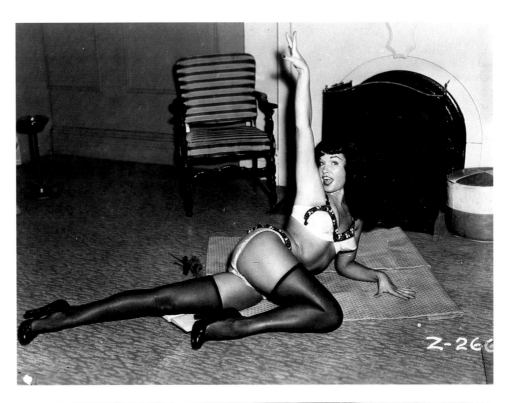

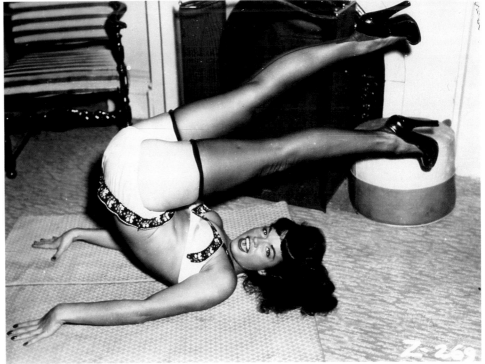

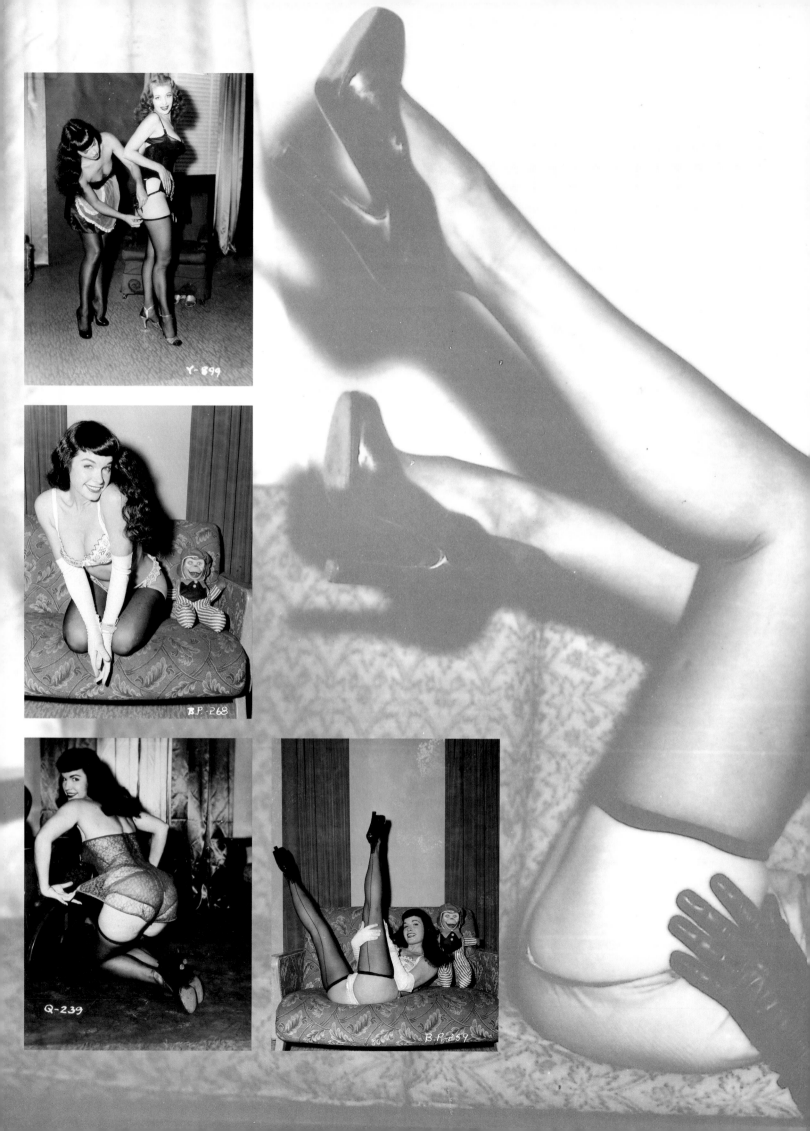

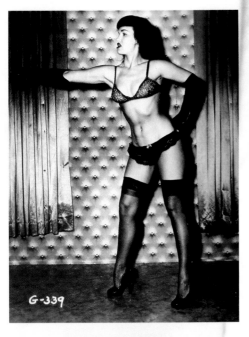

G-339

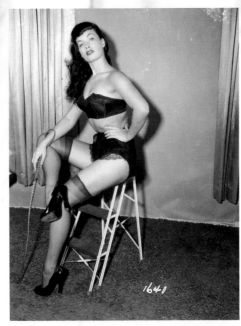

1641

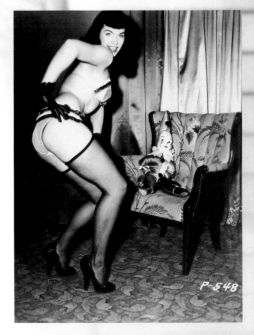

P-548

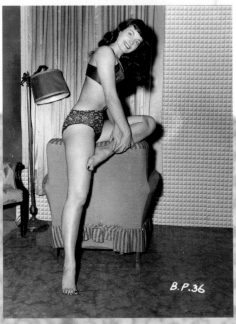

B.P.36

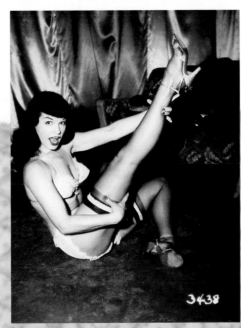

3438

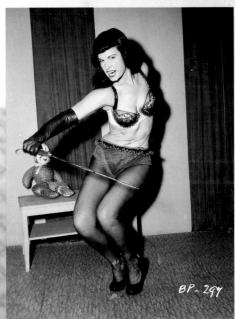

BP-297

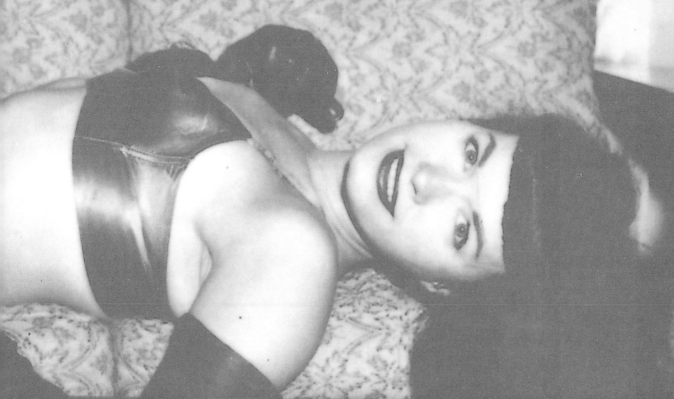

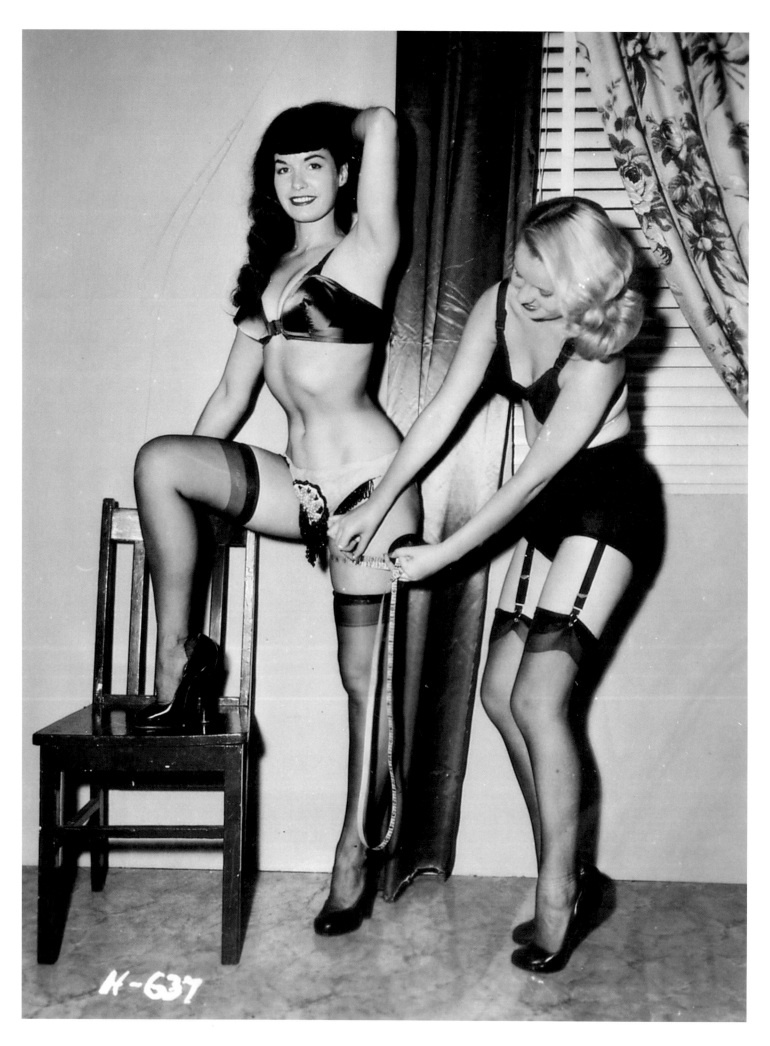

K-637

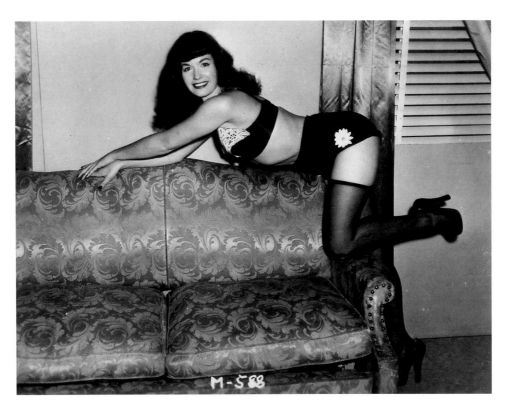

M-588

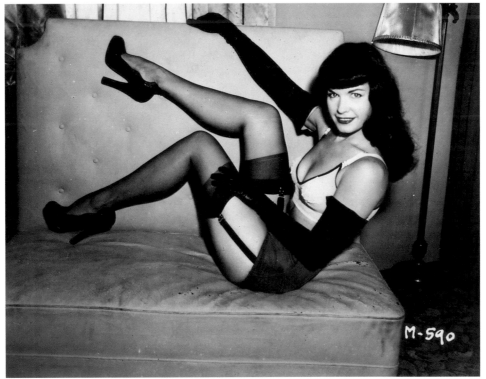

M-590

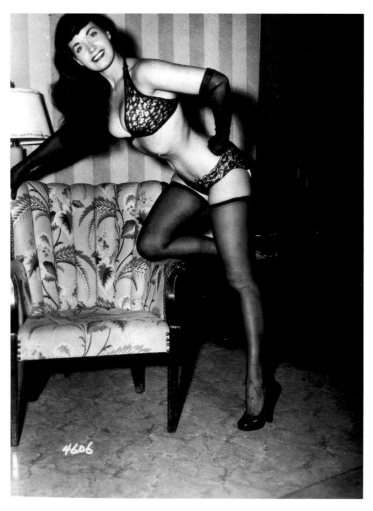

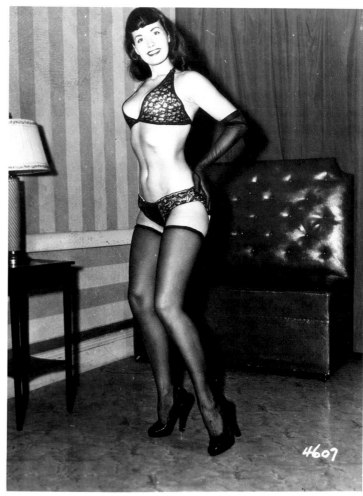

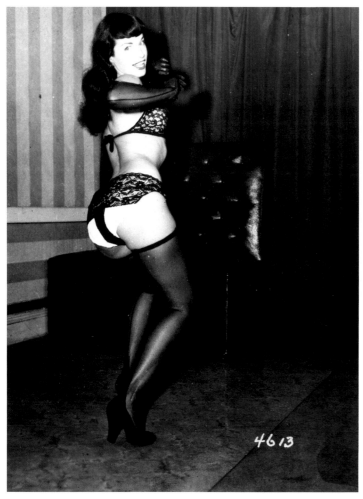

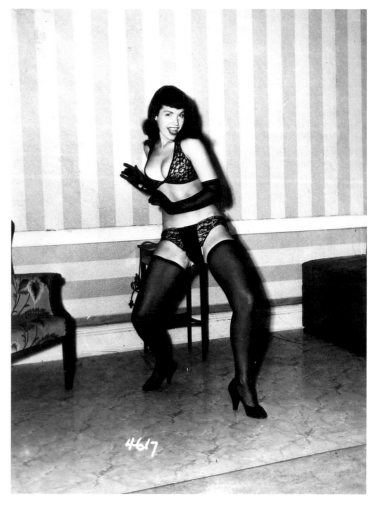

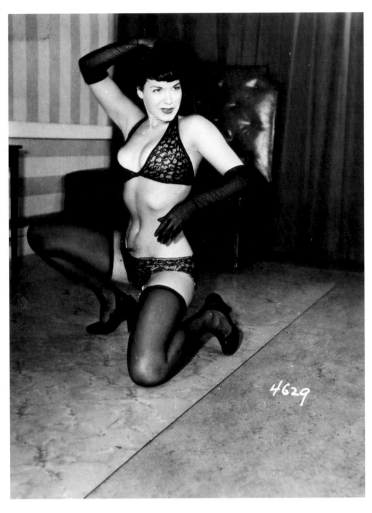

4629

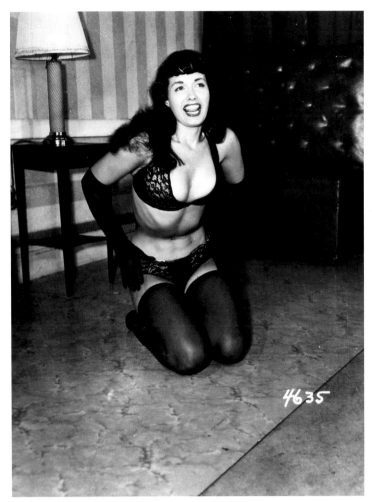

4635

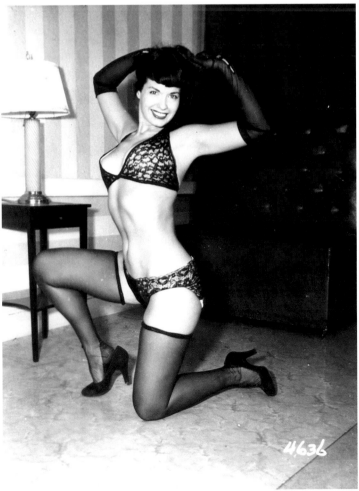

4636

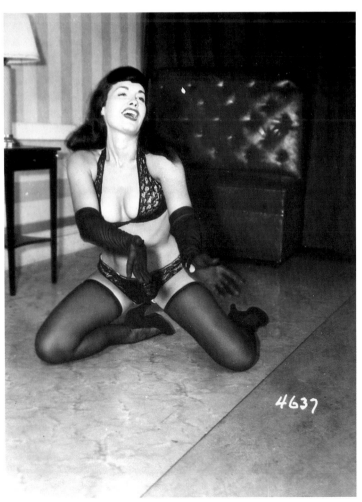

4637

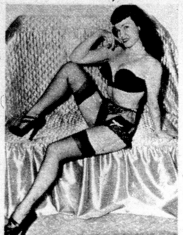 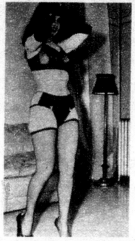 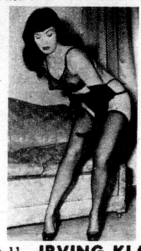 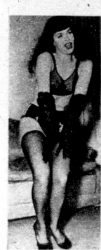

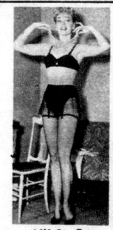
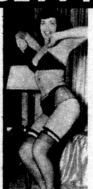
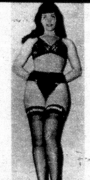
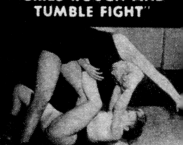

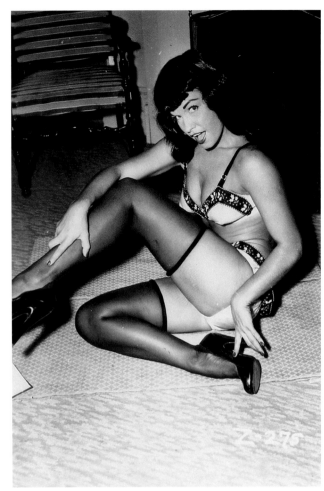

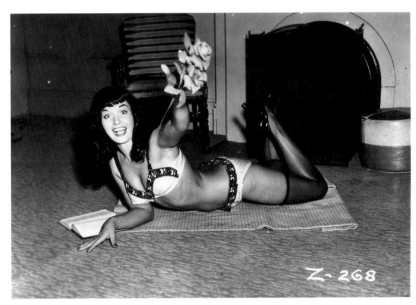

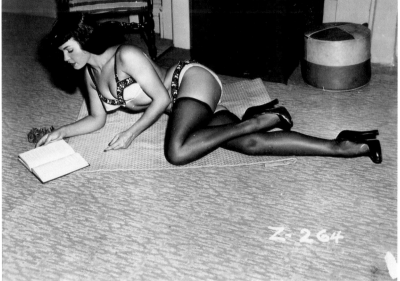

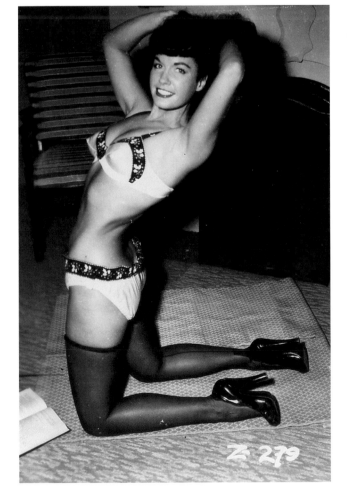

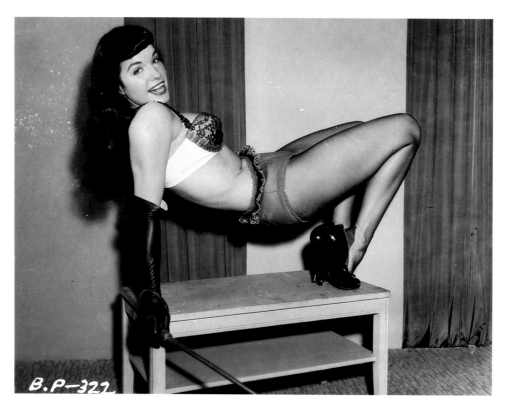

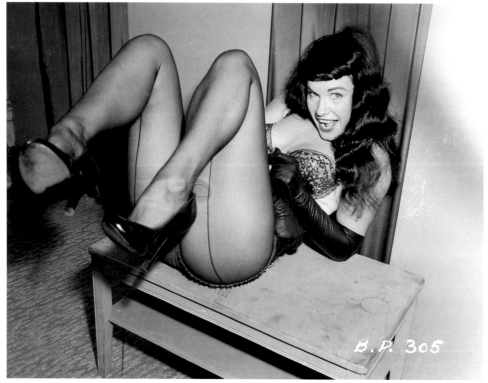

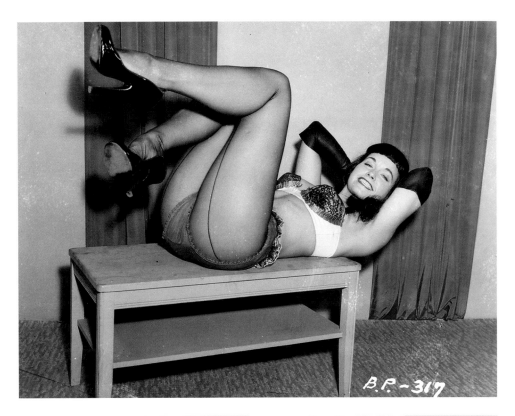

B.P.-317

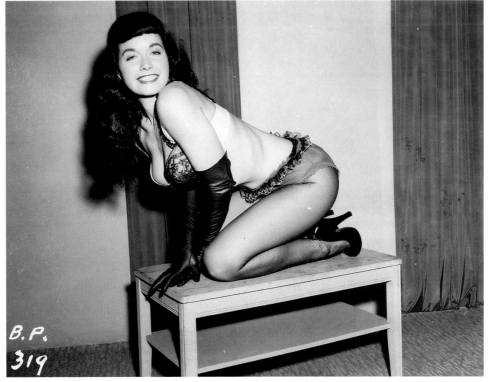

B.P.
319

33

DRIVING SCHOOL

JOE'S DRIVING SCHOOL

"ow let's see, turn on gas, put the clutch out, wind the window."

EYEFUL
Glorifying the American Girl
Oct. 25¢

CASA DEL GIORNALE
L. 450 -
A. G. NAPOLI

HOSE ⊙◍◍☆✿!!✳✱! Women Driv

EYEFUL
Glorifying the American Girl
AUGUST 25¢

ARE YOU BROAD-MINDED?
See page 24

QUICK MONEY IN STAMPS
BOLD
MARCH 1955 15¢
DANDRIDGE: Sex at its Hottest
BETTY PAGE

"Oh Gladys, I'm simply shocked! She did? Well . . ." This

"For heavens sake, if it isn't Herbie! Hiya Herb!

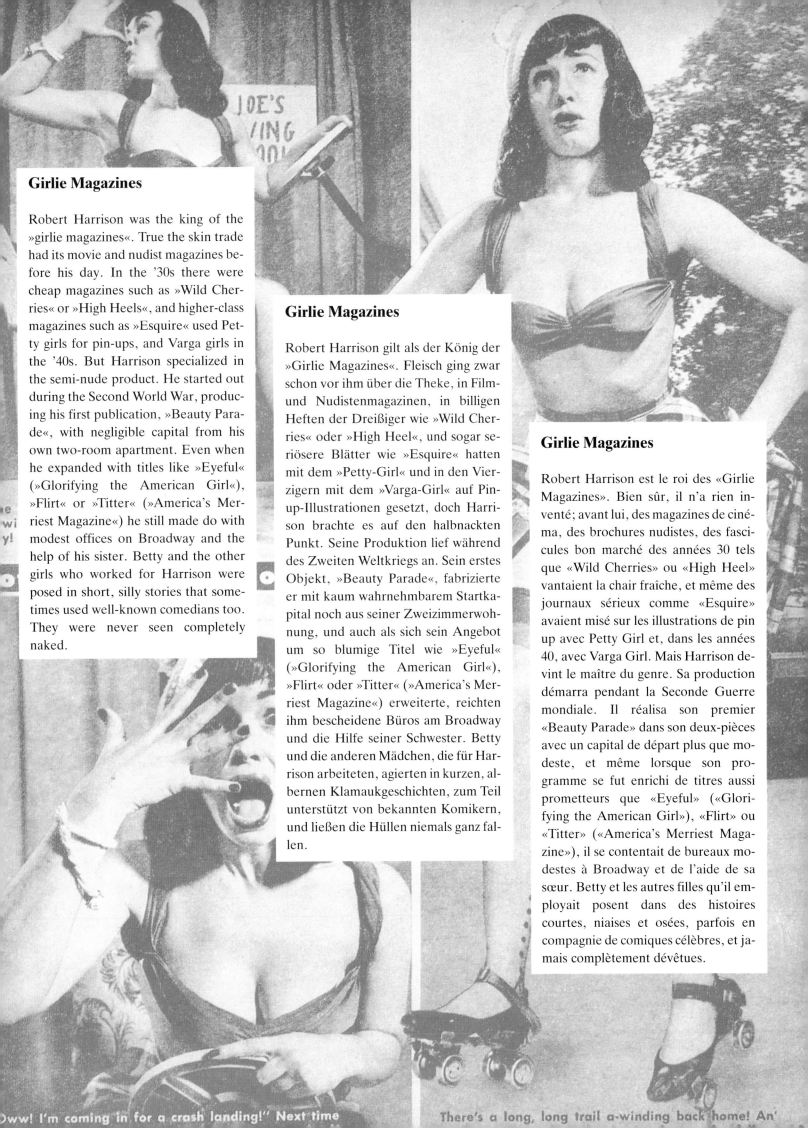

Girlie Magazines

Robert Harrison was the king of the »girlie magazines«. True the skin trade had its movie and nudist magazines before his day. In the '30s there were cheap magazines such as »Wild Cherries« or »High Heels«, and higher-class magazines such as »Esquire« used Petty girls for pin-ups, and Varga girls in the '40s. But Harrison specialized in the semi-nude product. He started out during the Second World War, producing his first publication, »Beauty Parade«, with negligible capital from his own two-room apartment. Even when he expanded with titles like »Eyeful« (»Glorifying the American Girl«), »Flirt« or »Titter« (»America's Merriest Magazine«) he still made do with modest offices on Broadway and the help of his sister. Betty and the other girls who worked for Harrison were posed in short, silly stories that sometimes used well-known comedians too. They were never seen completely naked.

Girlie Magazines

Robert Harrison gilt als der König der »Girlie Magazines«. Fleisch ging zwar schon vor ihm über die Theke, in Film- und Nudistenmagazinen, in billigen Heften der Dreißiger wie »Wild Cherries« oder »High Heel«, und sogar seriösere Blätter wie »Esquire« hatten mit dem »Petty-Girl« und in den Vierzigern mit dem »Varga-Girl« auf Pin-up-Illustrationen gesetzt, doch Harrison brachte es auf den halbnackten Punkt. Seine Produktion lief während des Zweiten Weltkriegs an. Sein erstes Objekt, »Beauty Parade«, fabrizierte er mit kaum wahrnehmbarem Startkapital noch aus seiner Zweizimmerwohnung, und auch als sich sein Angebot um so blumige Titel wie »Eyeful« (»Glorifying the American Girl«), »Flirt« oder »Titter« (»America's Merriest Magazine«) erweiterte, reichten ihm bescheidene Büros am Broadway und die Hilfe seiner Schwester. Betty und die anderen Mädchen, die für Harrison arbeiteten, agierten in kurzen, albernen Klamaukgeschichten, zum Teil unterstützt von bekannten Komikern, und ließen die Hüllen niemals ganz fallen.

Girlie Magazines

Robert Harrison est le roi des «Girlie Magazines». Bien sûr, il n'a rien inventé; avant lui, des magazines de cinéma, des brochures nudistes, des fascicules bon marché des années 30 tels que «Wild Cherries» ou «High Heel» vantaient la chair fraîche, et même des journaux sérieux comme «Esquire» avaient misé sur les illustrations de pin up avec Petty Girl et, dans les années 40, avec Varga Girl. Mais Harrison devint le maître du genre. Sa production démarra pendant la Seconde Guerre mondiale. Il réalisa son premier «Beauty Parade» dans son deux-pièces avec un capital de départ plus que modeste, et même lorsque son programme se fut enrichi de titres aussi prometteurs que «Eyeful» («Glorifying the American Girl»), «Flirt» ou «Titter» («America's Merriest Magazine»), il se contentait de bureaux modestes à Broadway et de l'aide de sa sœur. Betty et les autres filles qu'il employait posent dans des histoires courtes, niaises et osées, parfois en compagnie de comiques célèbres, et jamais complètement dévêtues.

Oww! I'm coming in for a crash landing!' Next time

There's a long, long trail a-winding back home! An'

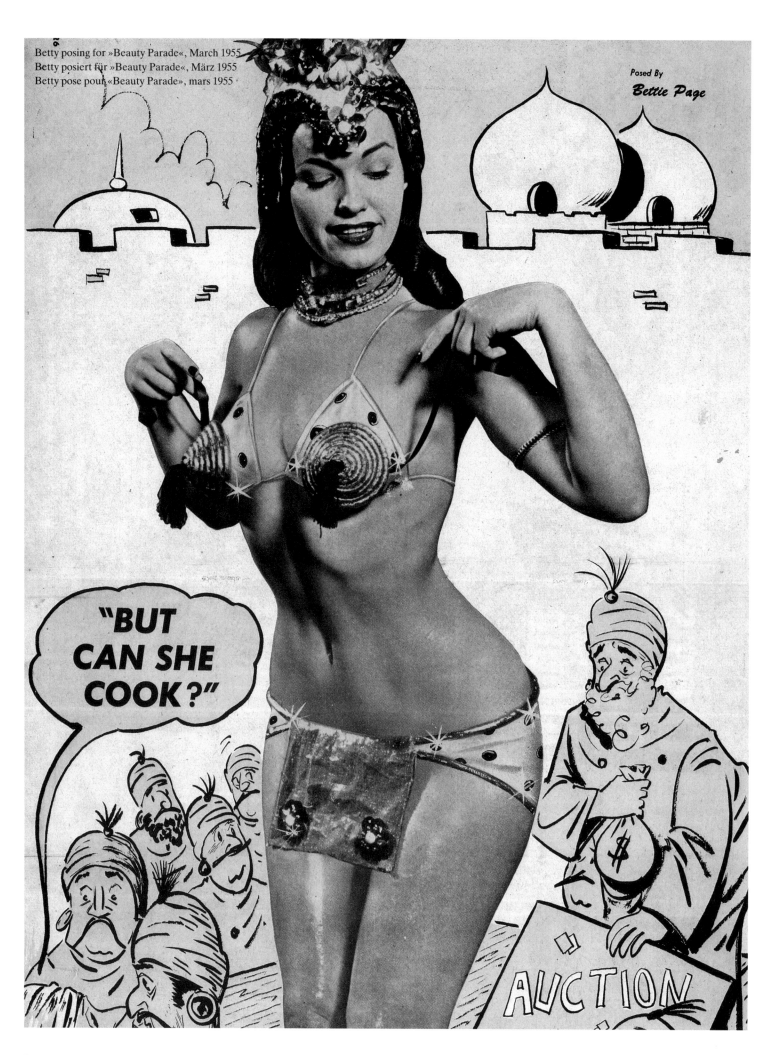

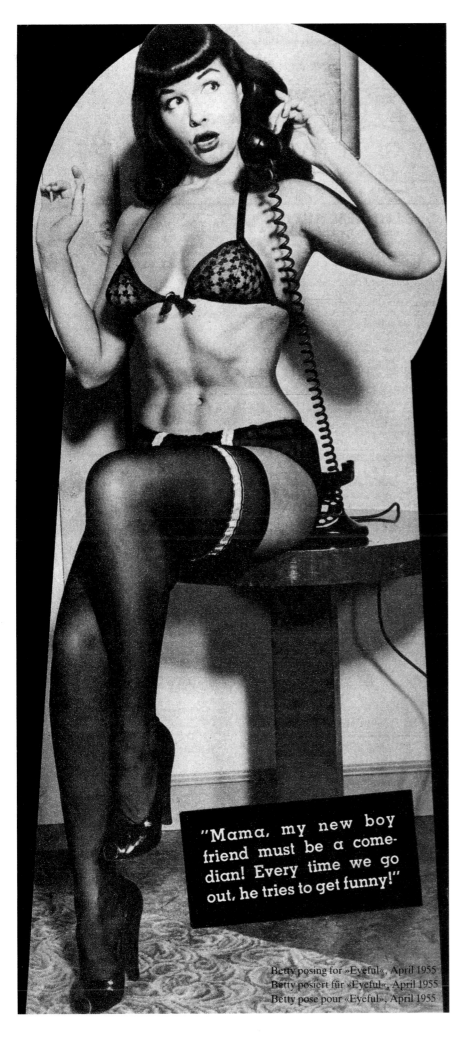

"Mama, my new boy friend must be a comedian! Every time we go out, he tries to get funny!"

Betty posing for »Eyeful«, April 1955
Betty posiert für »Eyeful«, April 1955
Betty pose pour «Eyeful», April 1955

Betty posing for »Eyeful«, February 1954
Betty posiert für »Eyeful«, Februar 1954
Betty pose pour «Eyeful», février 1954

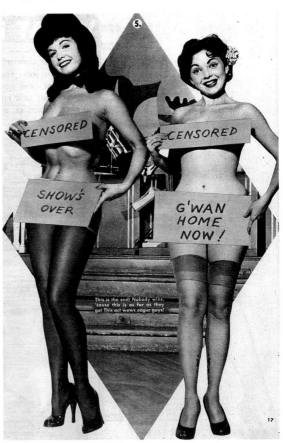

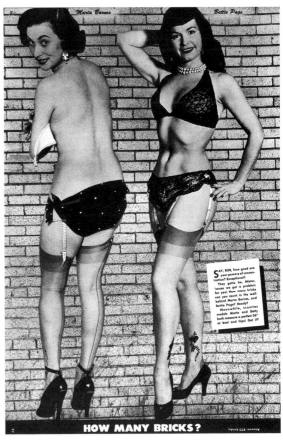

Betty posing for »Double A-Peel«, March 1955
Betty posiert für »Double A-Peel«, März 1955
Betty pose pour «Double A-Peel», mars 1955

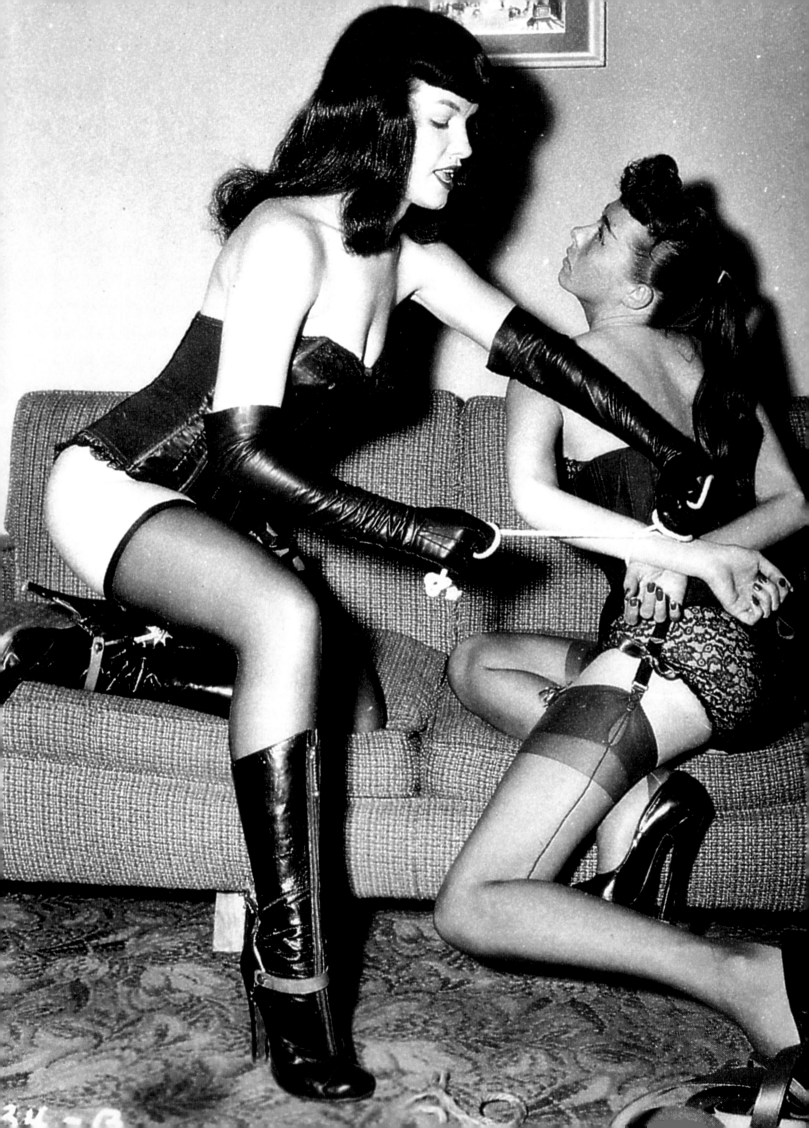

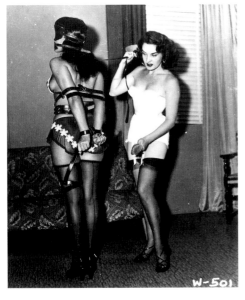

W-501

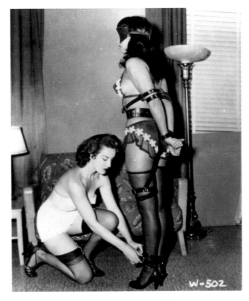

W-502

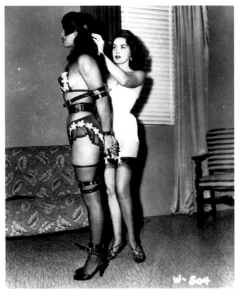

W-504

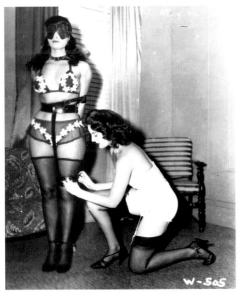

W-505

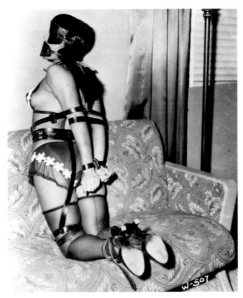

W-507

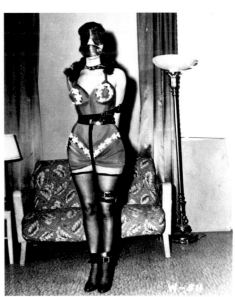

W-511

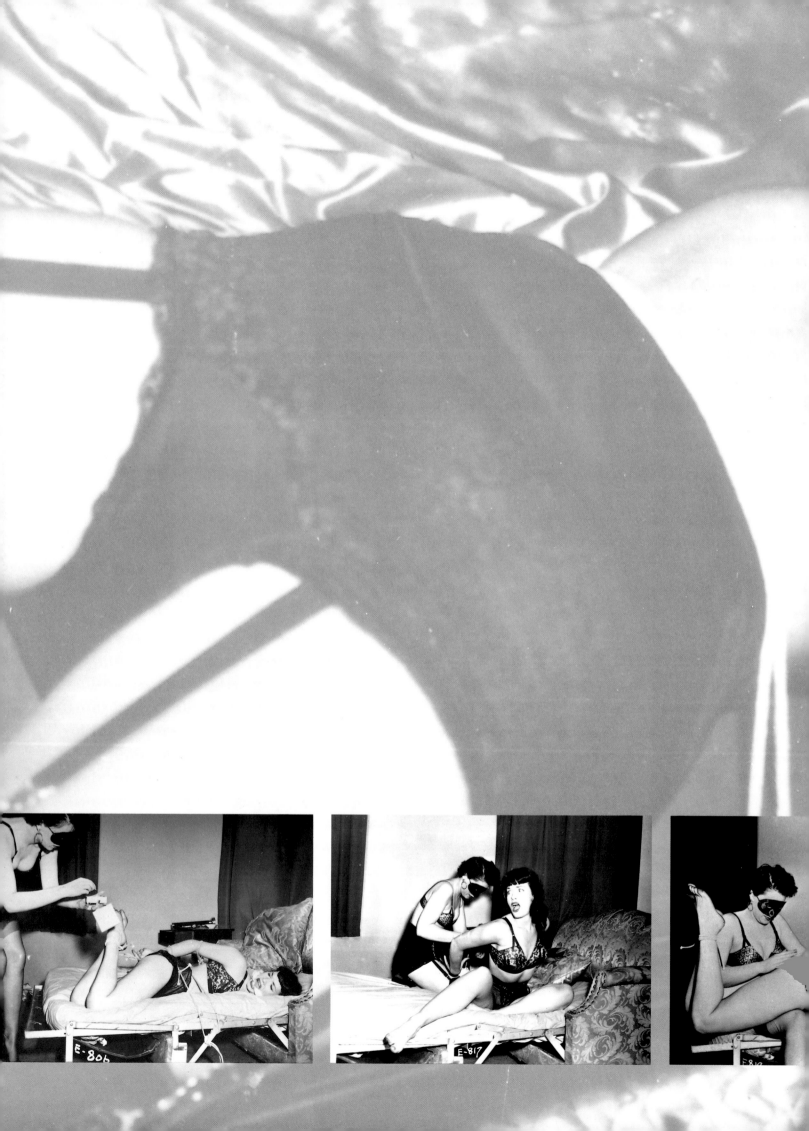

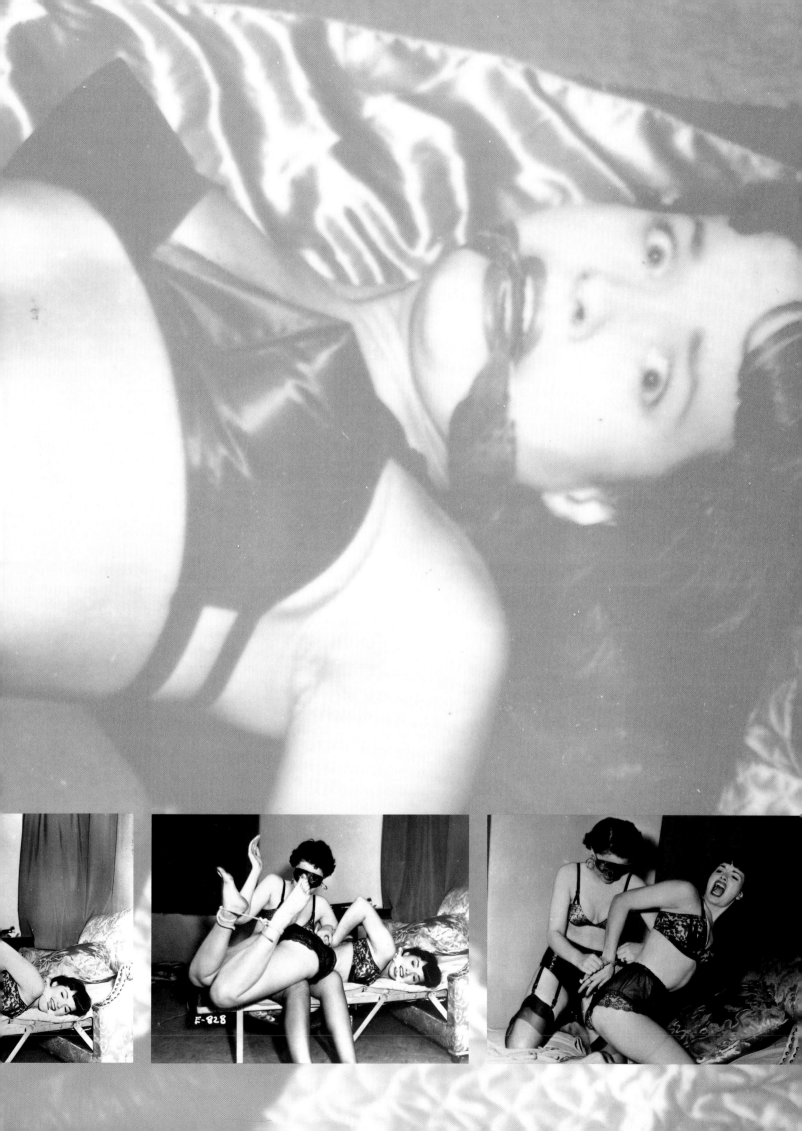

F-828

Bondage

Miss Page, would you kindly stop laughing! The woman in the room looks as if she's about to be tied up, the woman entering plainly has only that one thing on her mind. It is a game in which the roles can easily be reversed. In contrast to the bondage photos of the master, John Willie, which often look as if they were taken at the scene of some crime, Klaw's bondage photos of Betty lack both brutality and seriousness. Furthermore, there are no men.

Bondage

Miss Page, hören Sie auf zu lachen! Die Frau im Zimmer sieht aus, als würde sie gleich gefesselt, die Frau, die eintritt, hat nichts anderes im Sinn. Ein Spiel, bei dem Opfer und Täter problemlos die Rollen tauschen können. Anders als etwa in den Fotografien des Bondage-Großmeisters John Willie, die gerne wie Tatort-Aufnahmen wirken, fehlt Klaws Bondage-Fotos mit Betty jede Spur von Brutalität und jede Möglichkeit von Ernst. Und aufpassen: Männer spielen hier nicht mit.

L'esclave

Miss Page, cessez de rire! La femme qui se trouve dans cette chambre va être enchaînée, celle qui entre dans la pièce ne laisse aucun doute à ce sujet. Le bourreau et la victime peuvent aisément échanger leurs rôles. Mais les photos que Klaw a prises de Betty sont absolument dénuées de brutalité, impossible de les prendre au sérieux. Il en va tout autrement par exemple des photographies de John Willie, le maître incontesté du genre, qui semblent prises sur le lieu du crime. Une remarque s'impose: ici, les femmes sont entre elles.

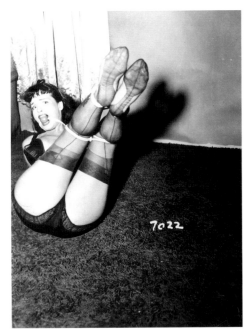

7022

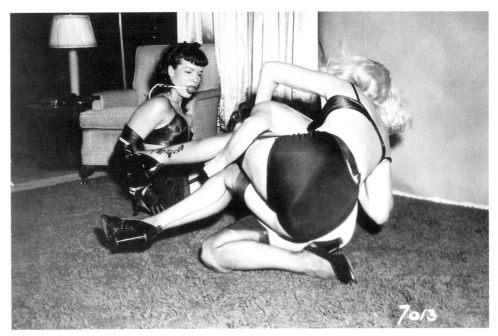

7013

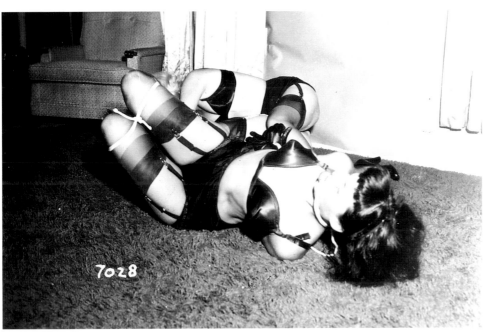

7028

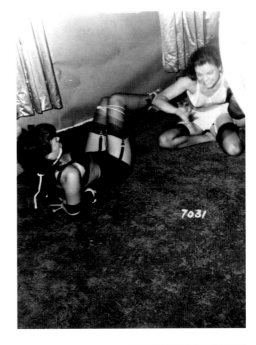

7031

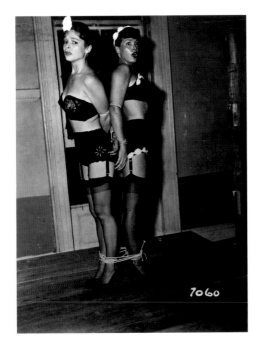

7060

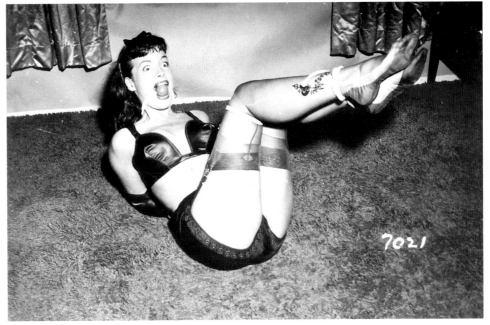

7021

43

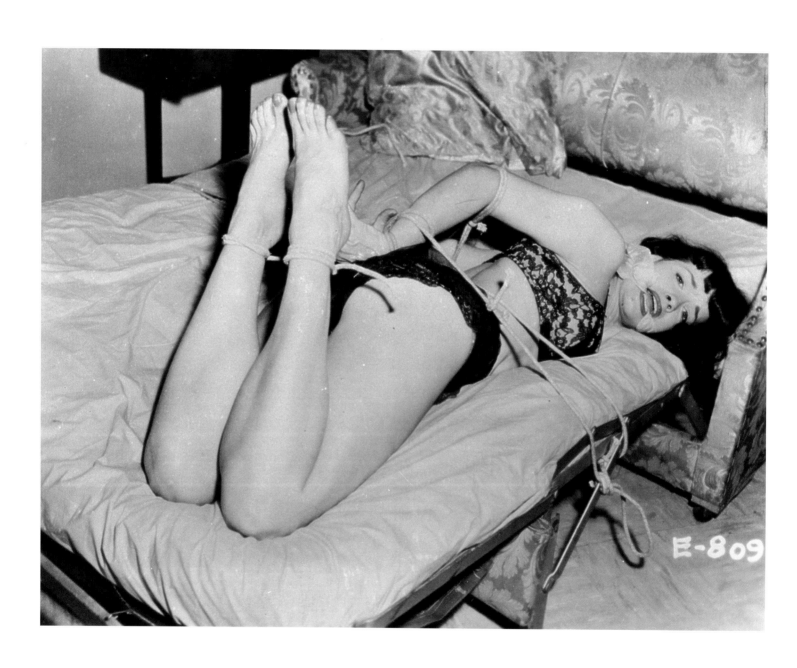

E-809

44

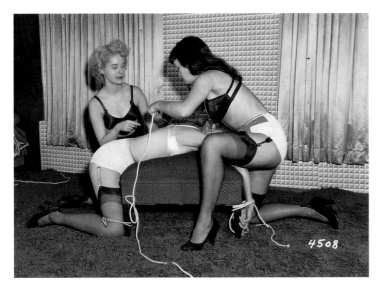

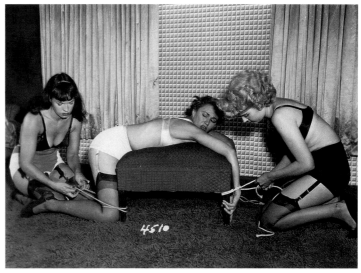

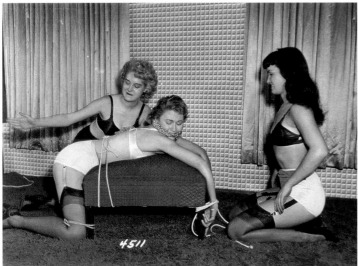

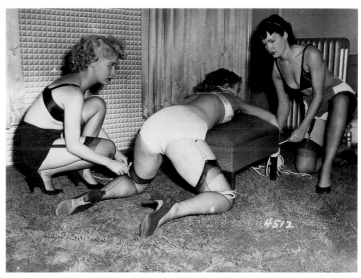

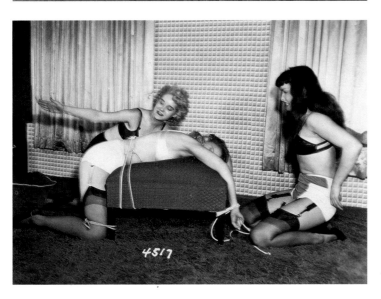

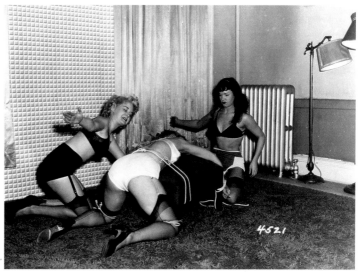

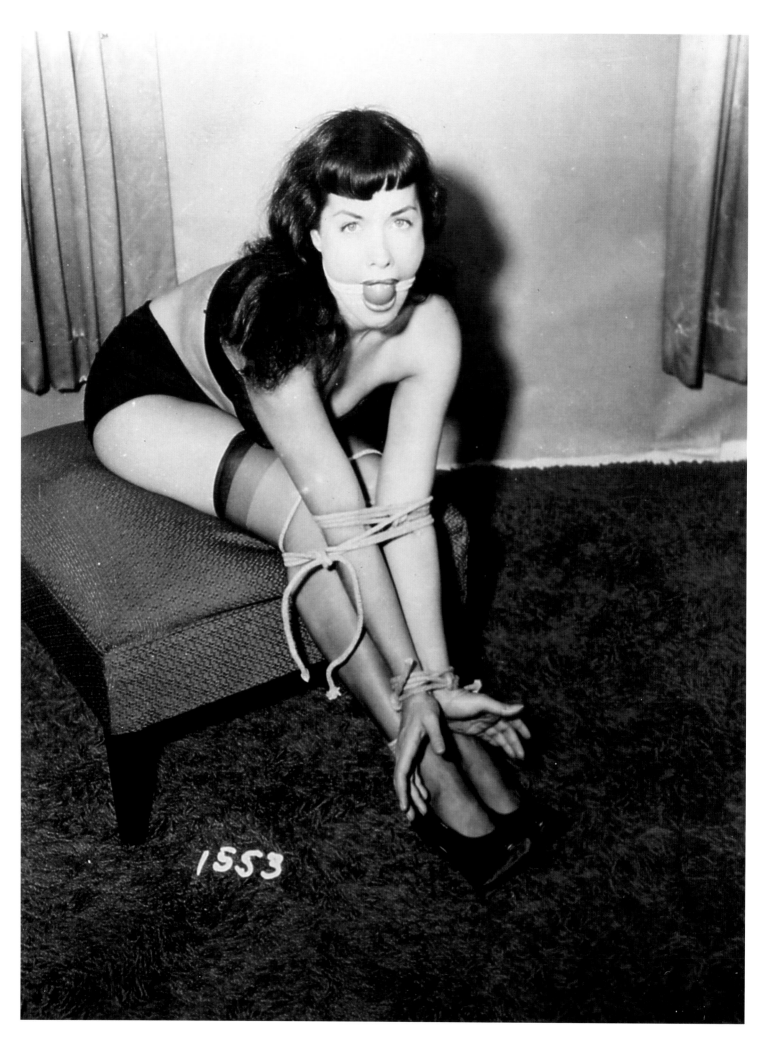

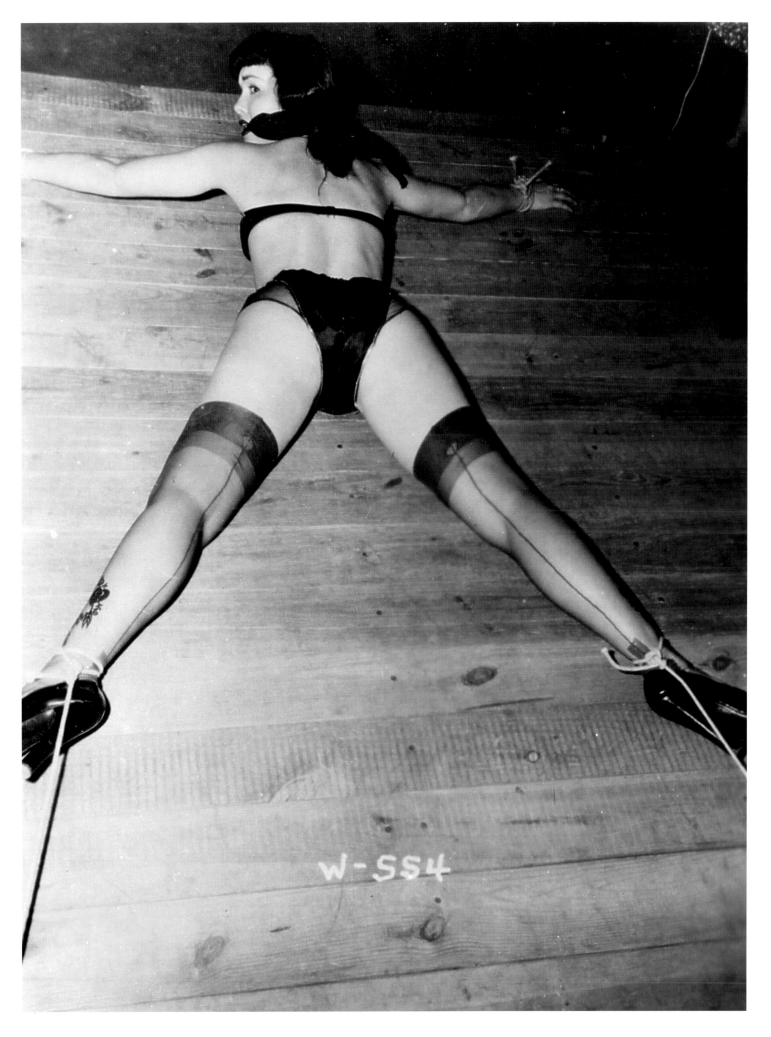

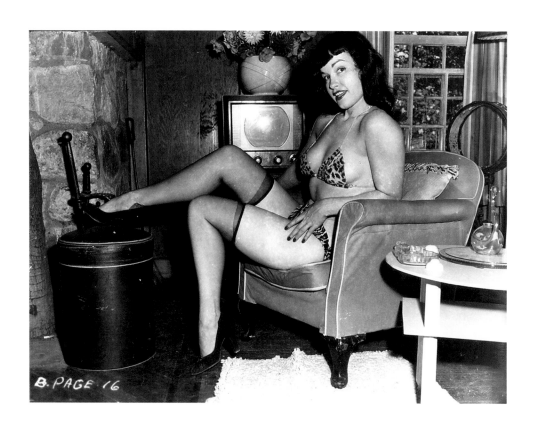

Right/rechts/à droite:
Betty posing for »Playboy«, 1955
Betty posiert für »Playboy«, 1955
Betty pose pour «Playboy», 1955

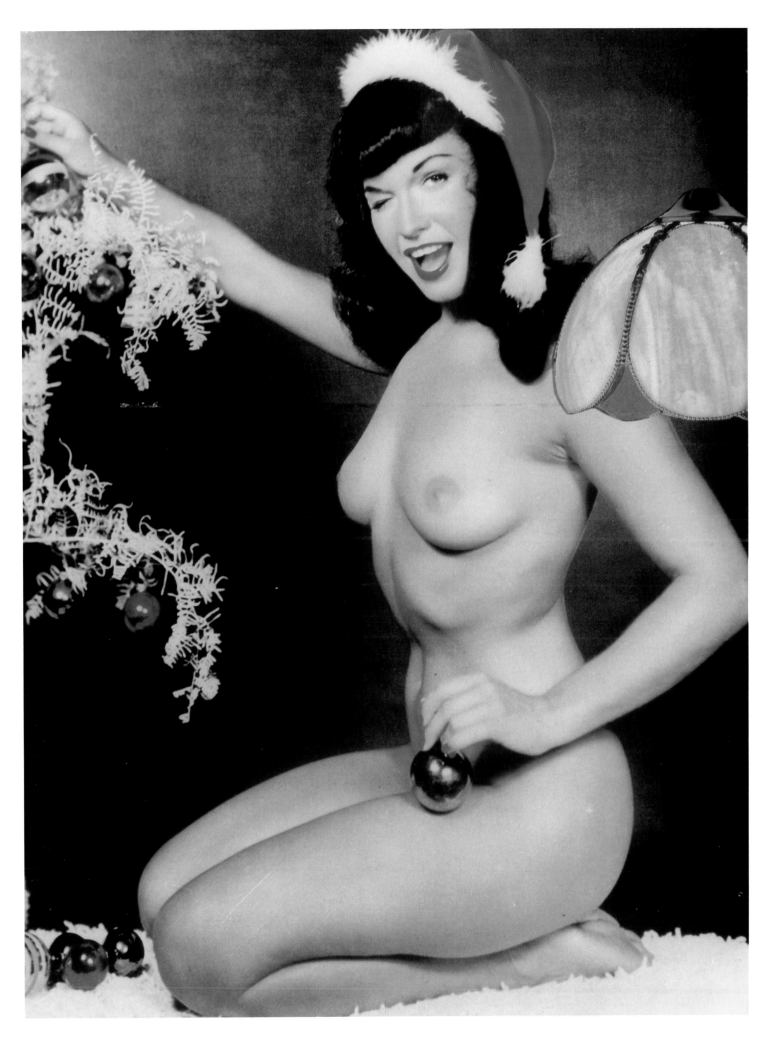

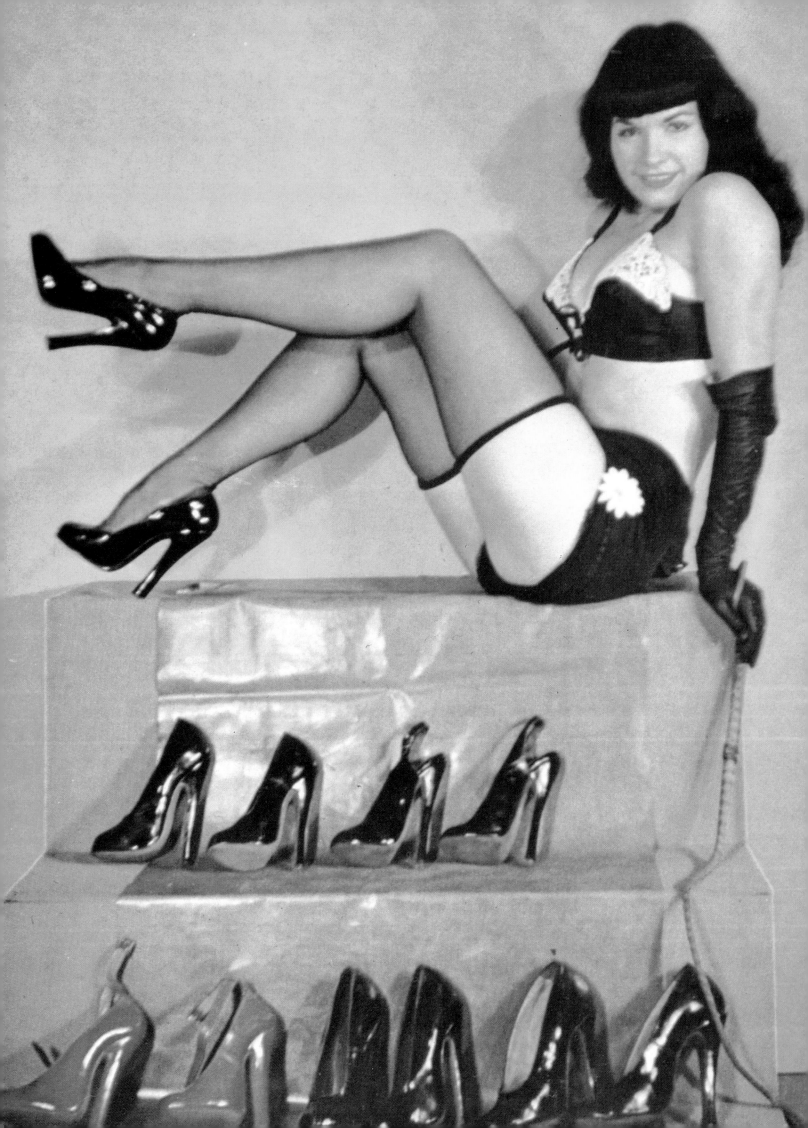

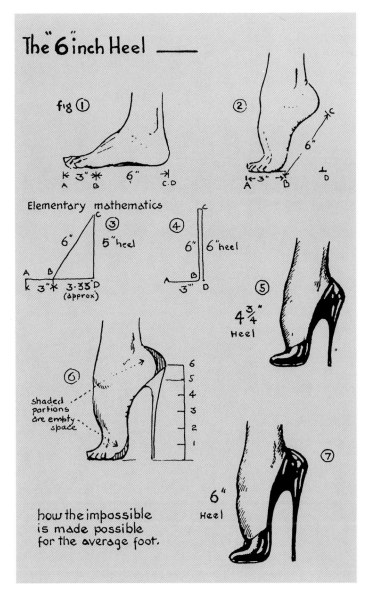

From: »Bizarre«, No. 12, 1954
Aus: »Bizarre«, Nr. 12, 1954
Extrait de: «Bizarre», n° 12, 1954

High-Heels

Besides whips, suspender belts and lace underwear, high heels constitute an integral part of Betty's armoury. She apparently owned more than 150 pairs of shoes, with extra high heels being her absolute speciality. 20 cm or more pose no problem for Betty.

High-Heels

Neben Peitsche, Strapsen und Spitzen-Wäsche sind High-Heels ein fester Bestandteil von Bettys Standardbewaffnung. In ihrer Schuhsammlung sollen sich über 150 Paare befunden haben, wobei Ultra-High-Heels ihre absolute Spezialität waren. 20 cm und mehr bedeuten für Betty kein Problem.

High-Heels

Les talons hauts font partie de la panoplie standard de Betty à côté de la cravache, du porte-jarretelles et de la lingerie fine. On dit qu'elle en possédait 150 paires. Les talons très, très hauts étaient sa spécialité: 20 cm et davantage ne lui faisaient pas peur.

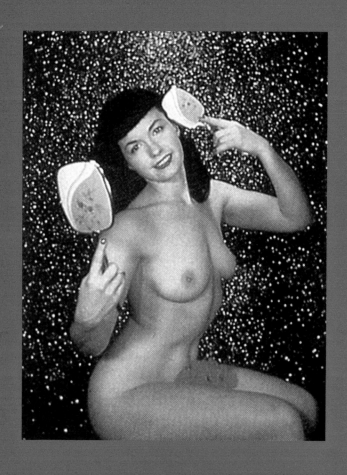

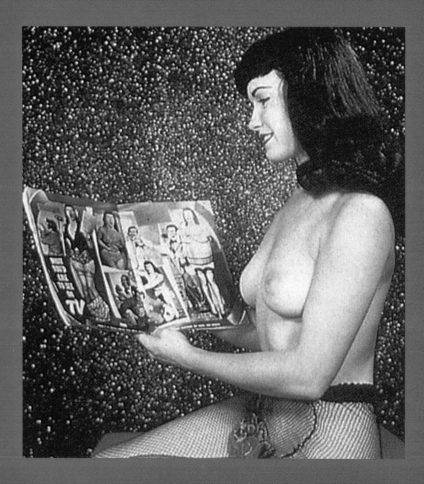

Private photo sessions, 1953–56
Privataufnahmen, 1953–56
Betty en privé, 1953–56

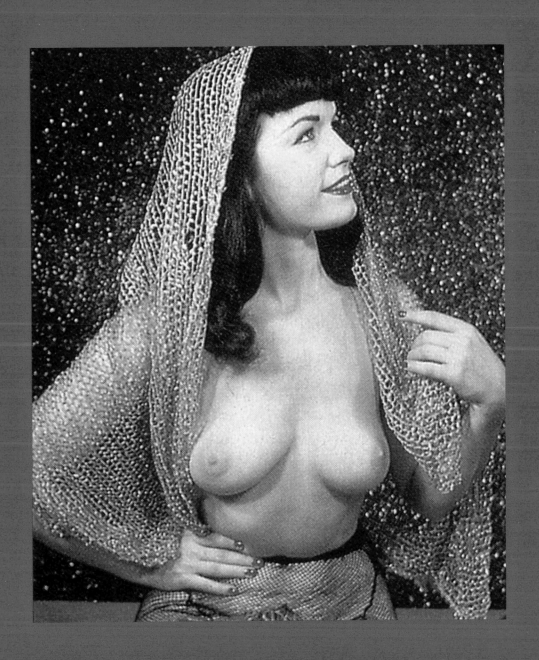

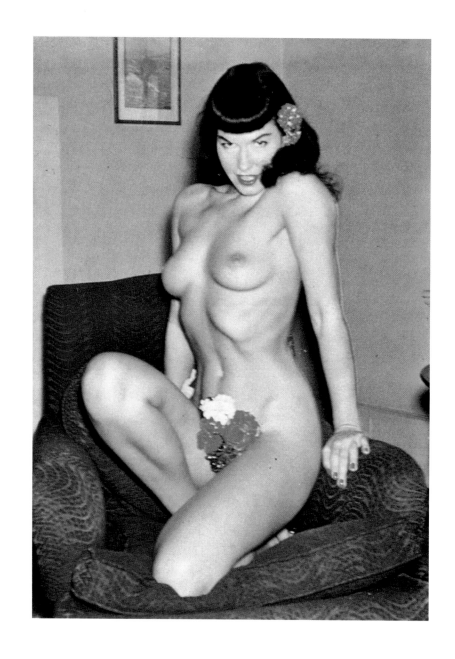

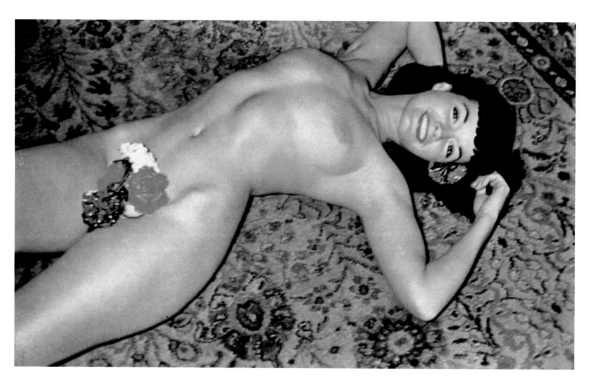

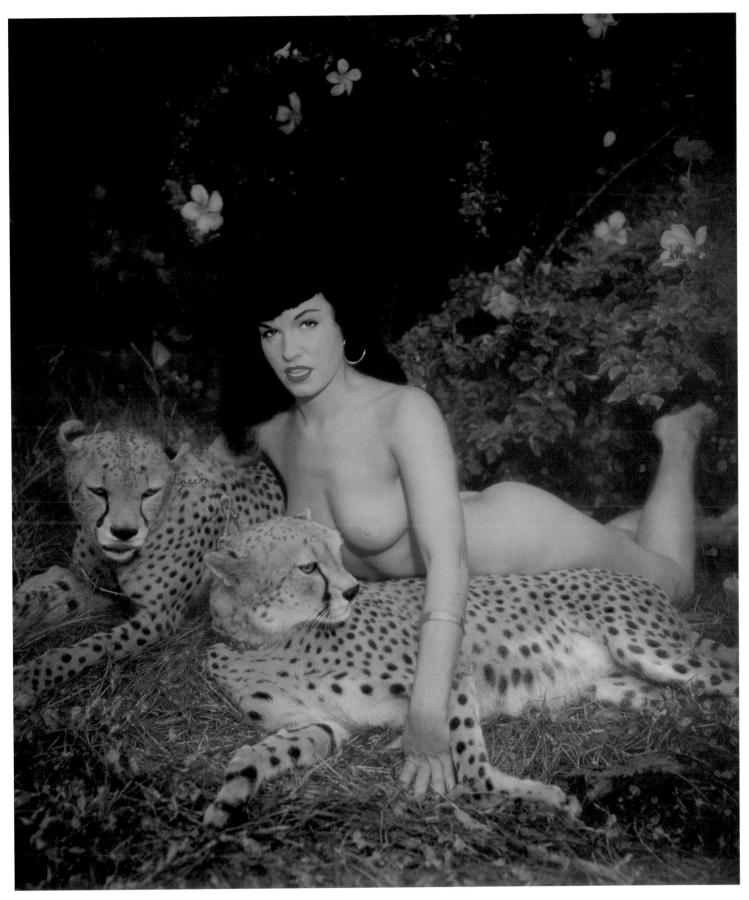

Photo: Bunny Yeager, 1955–57

Left/links/à gauche:
Private photo sessions, 1950–53
Privataufnahmen, 1950–53
Betty en privé, 1950–53

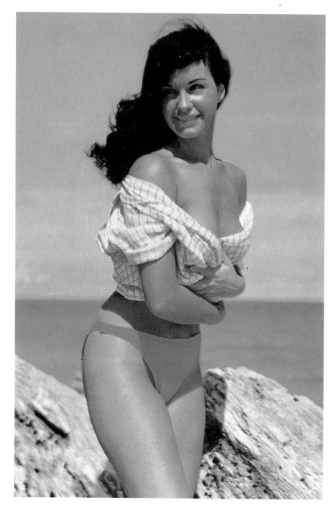

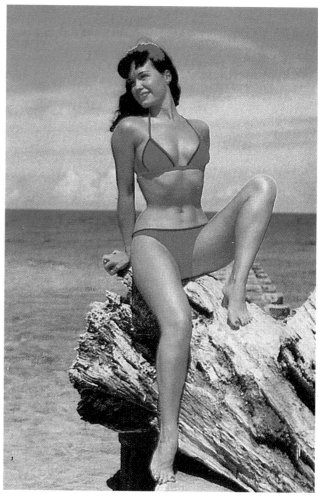

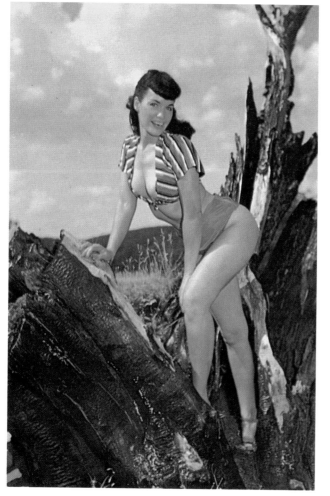

Postcard motifs, Miami, 1955
Postkartenmotive, Miami, 1955
Motifs de cartes postales, Miami, 1955

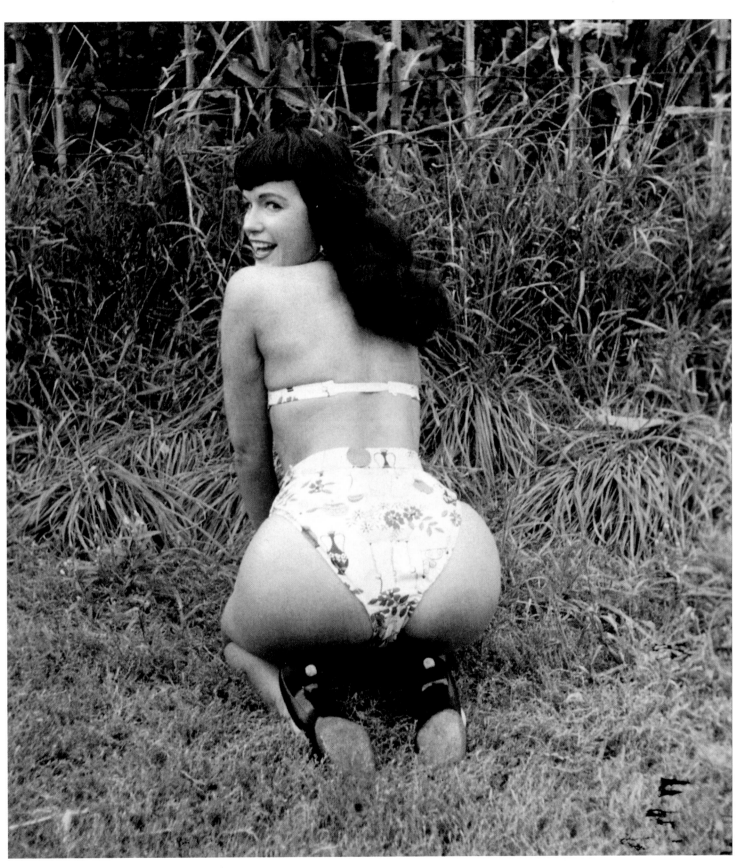

Betty in Boca Ranton Park, Miami, 1954
Betty im Boca Ranton Park, Miami, 1954
Betty dans le Boca Ranton Park, Miami, 1954

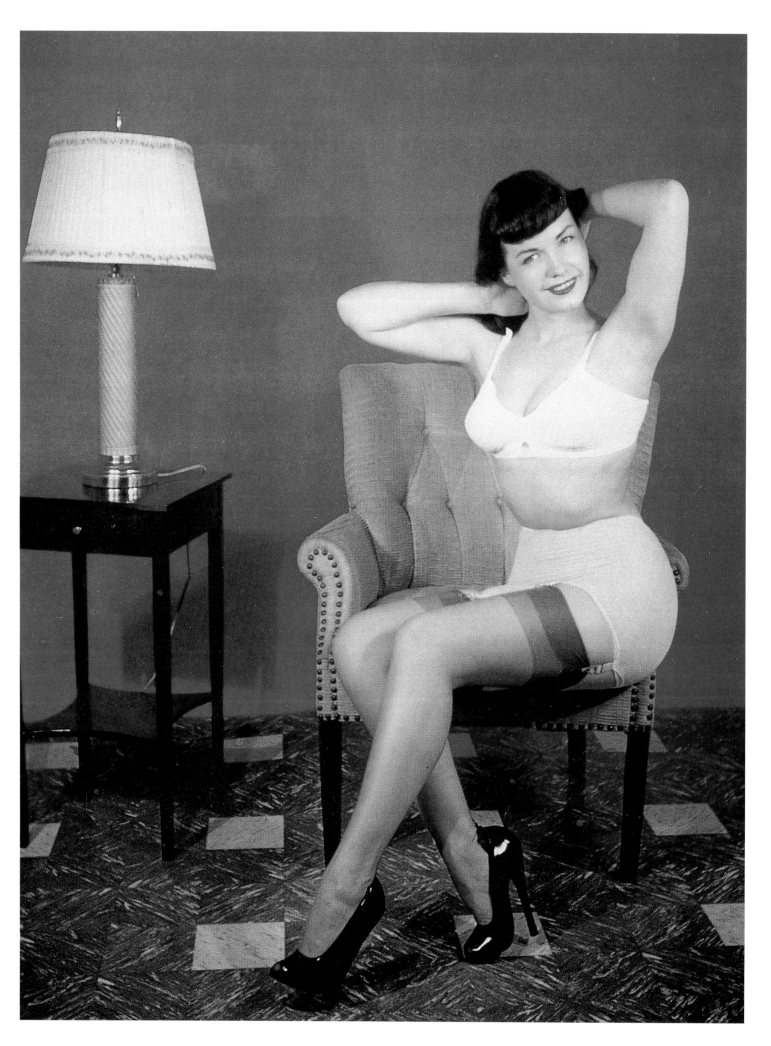

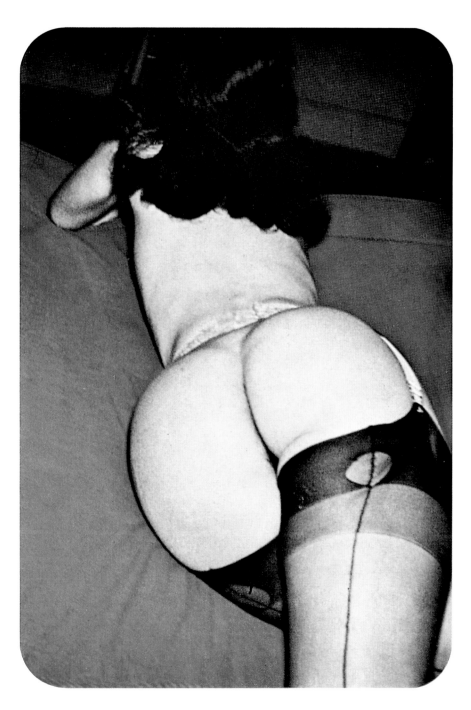

Private photo sessions, 1950–53
Privataufnahmen, 1950–53
Betty en privé, 1950–53

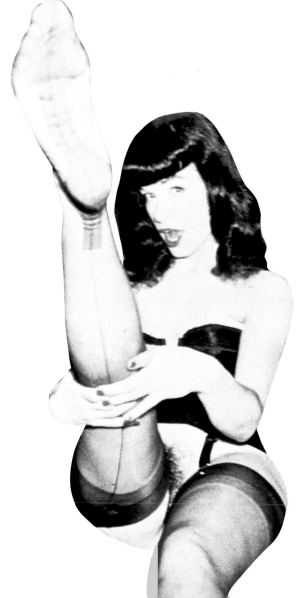

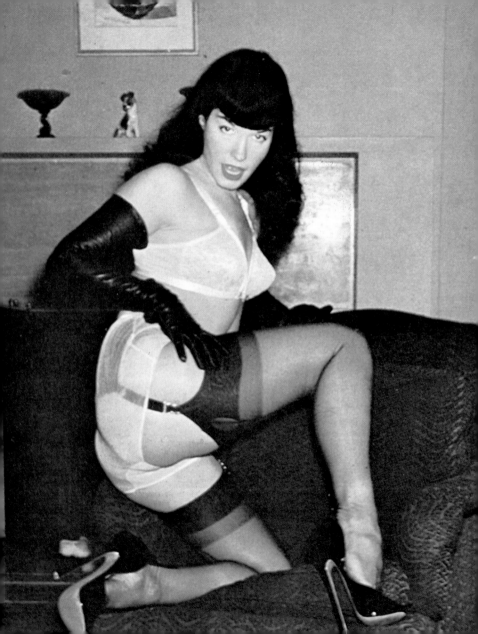

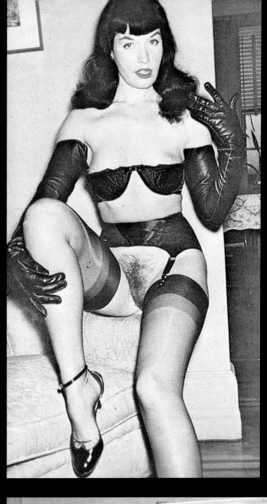
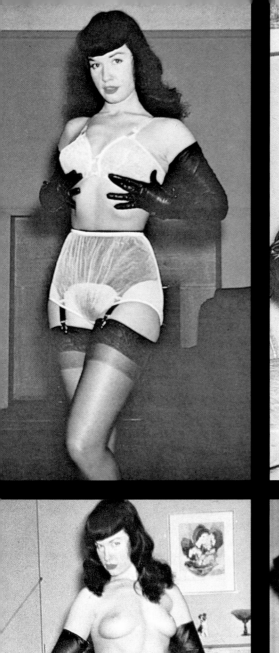
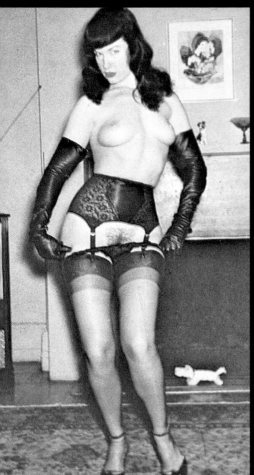
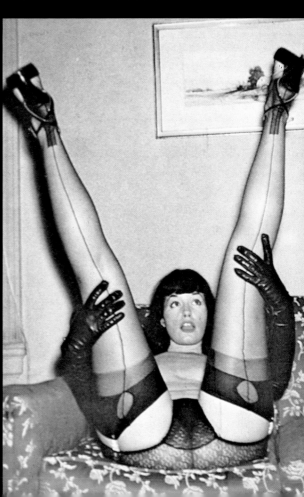

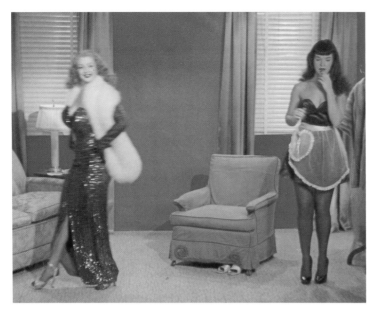 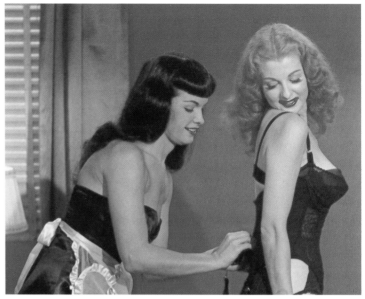

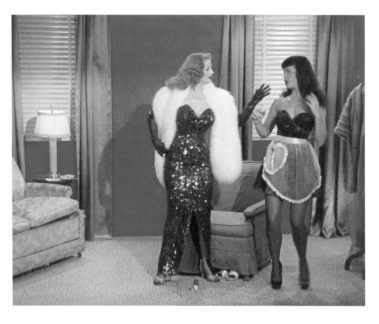 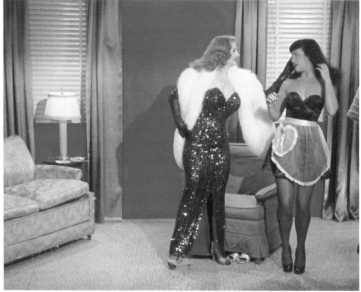

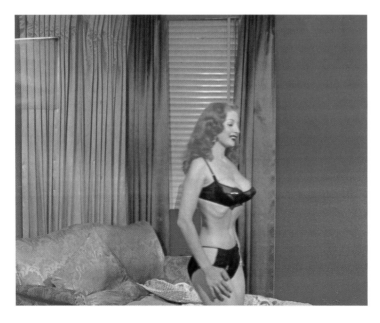 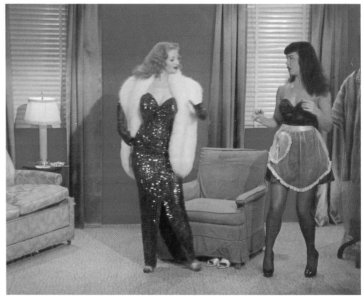

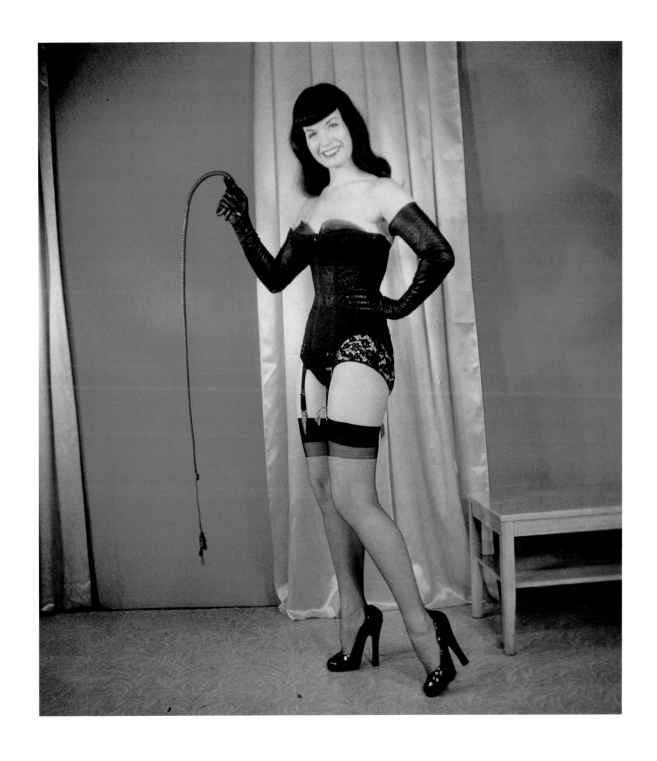

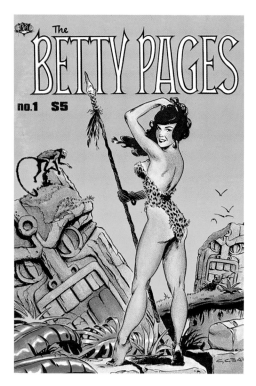

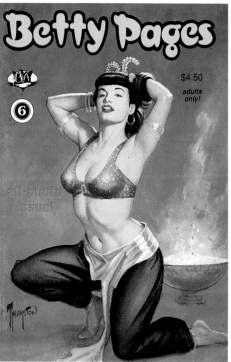

Betty Page Fanzines, 1980s
Betty Page Fanzines, 80er Jahre
Fanzines Betty Page, années 80

The Betty Page Revival

Nowadays Betty is everywhere. 35 years after she quit the stage so mysteriously, Betty Page has become a cult figure for a generation that can scarcely even have seen the dog-eared mags in the attic. The number of fans who associate her with trashbeat, rock 'n' roll, and the teenage life-style is probably greater than the stuffy collectors of pin-ups. Betty is on buttons and badges, T-shirts, cards and record covers. She is in fanzines, comics and bumper photo books. In the States, there are always entrants at Betty Page lookalike contests. There is a Betty Page fan club. Videos of her bondage and dance routines are popular at parties. And Betty even comes dressed as Santa Claus on a Christmas card.

Revival

Betty ist heute überall. 35 Jahre nach ihrem geheimnisvollen Abgang ist Betty Page zum Kultstar einer Generation geworden, der Betty höchstens in abgegriffenen Kartons auf dem Speicher begegnet sein kann. Und die Zahl derer, die sie in einem Zusammenhang mit »Trashbeat«, Rock and Roll (R 'n' R) und »teenage lifestyle« sehen, dürfte die biederer Pin-up-Sammler um einiges übertreffen. Betty auf Buttons, Betty auf T-Shirts, auf Trading-Cards und Plattencovern, Betty in Fanzines (Fan-Magazinen), Comics und in voluminösen Prachtbänden. Betty-Page-lookalike-Contests können zumindest in den Staaten auf rege Teilnahme hoffen. Es gibt mit den »Betty Pages« das Zentralorgan der Fan-Gemeinde, Videos mit ihren Bondage- und Tanznummern sind beliebte Party-Tapes, und als Weihnachtskarte kann man Betty im Santa-Claus-Kostüm verschicken.

Le retour

35 ans après sa mystérieuse disparition, Betty Page est devenue la star d'une génération qui ne peut l'avoir découverte qu'au grenier dans de vieux cartons. Et ceux qui la rapprochent de Trashbeat, R'n'R et teenage lifestyle sont certainement plus nombreux que les braves collectionneurs de pin up. Betty sur les boutons, sur les T-shirts, les cartes à collectionner et les couvertures de disques, Betty dans les magazines de ses fans, les bandes dessinées et de volumineux ouvrages de prix élevé. Les concours de sosies Betty Page ont de nombreuses participantes, du moins aux Etats-Unis. Les «Betty Page» sont l'organe central de ses groupements d'admirateurs, les vidéocassettes où elle joue à l'esclave ou à la danseuse sont appréciées dans les soirées, et on trouve même Betty en père Noël sur les cartes de Noël.

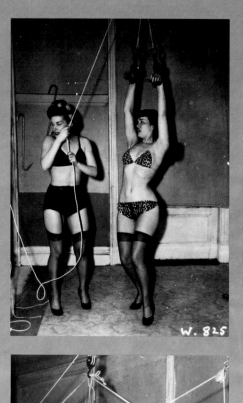

W. 825

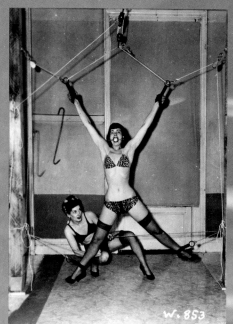

W. 853

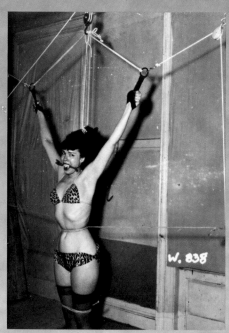

W. 838

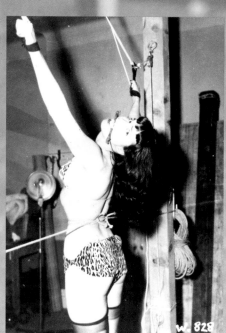

W. 828

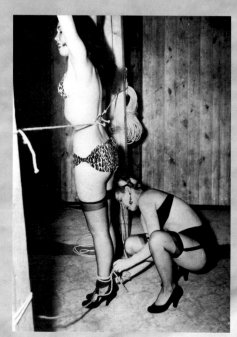

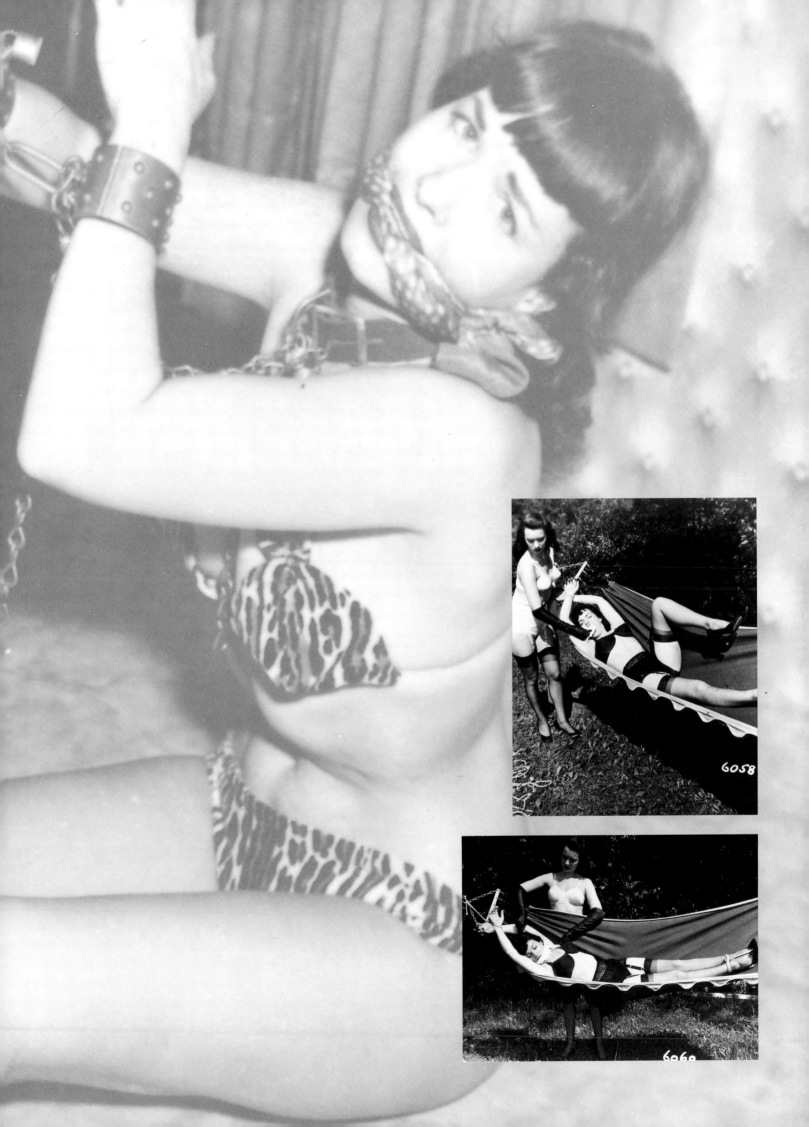

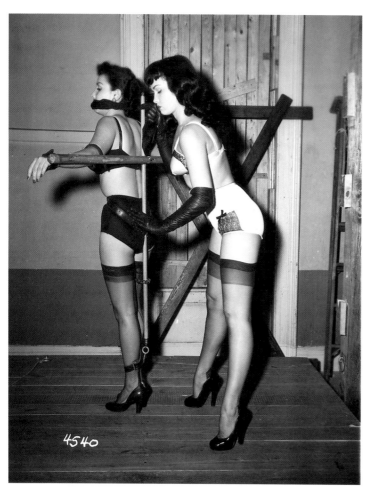

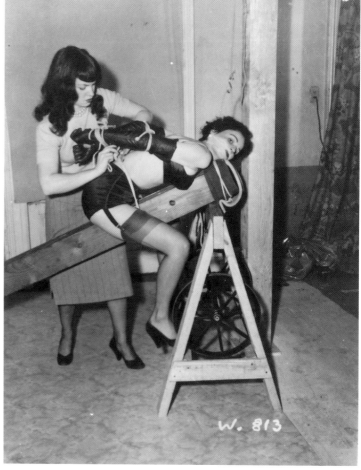

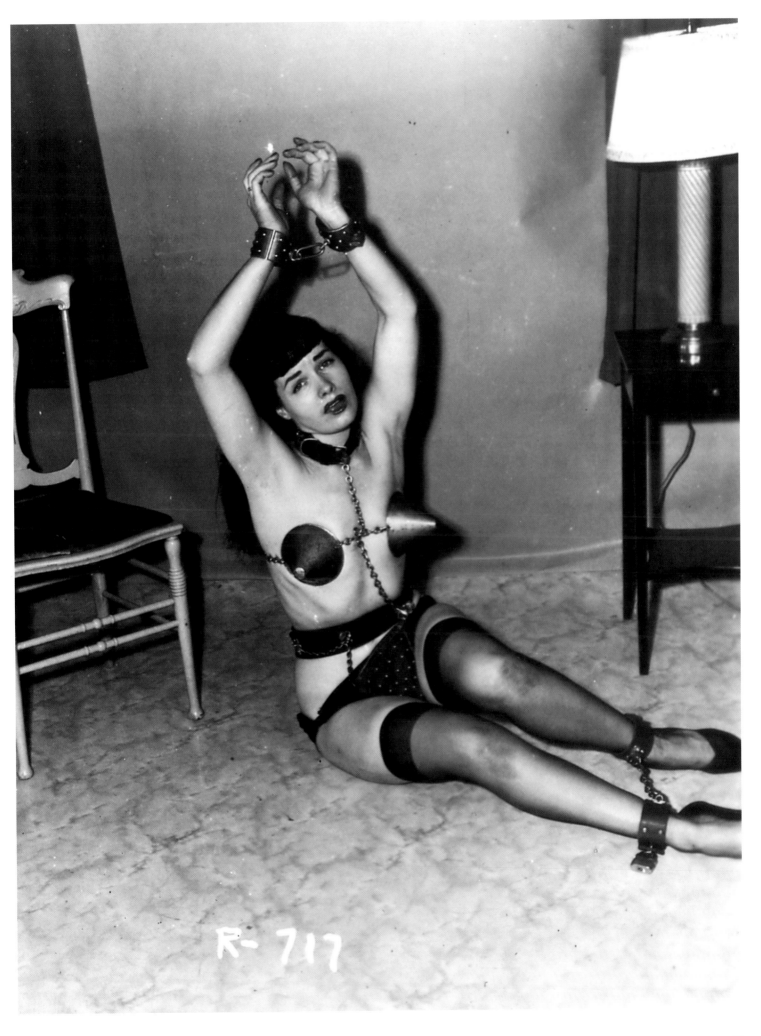

R- 717

69

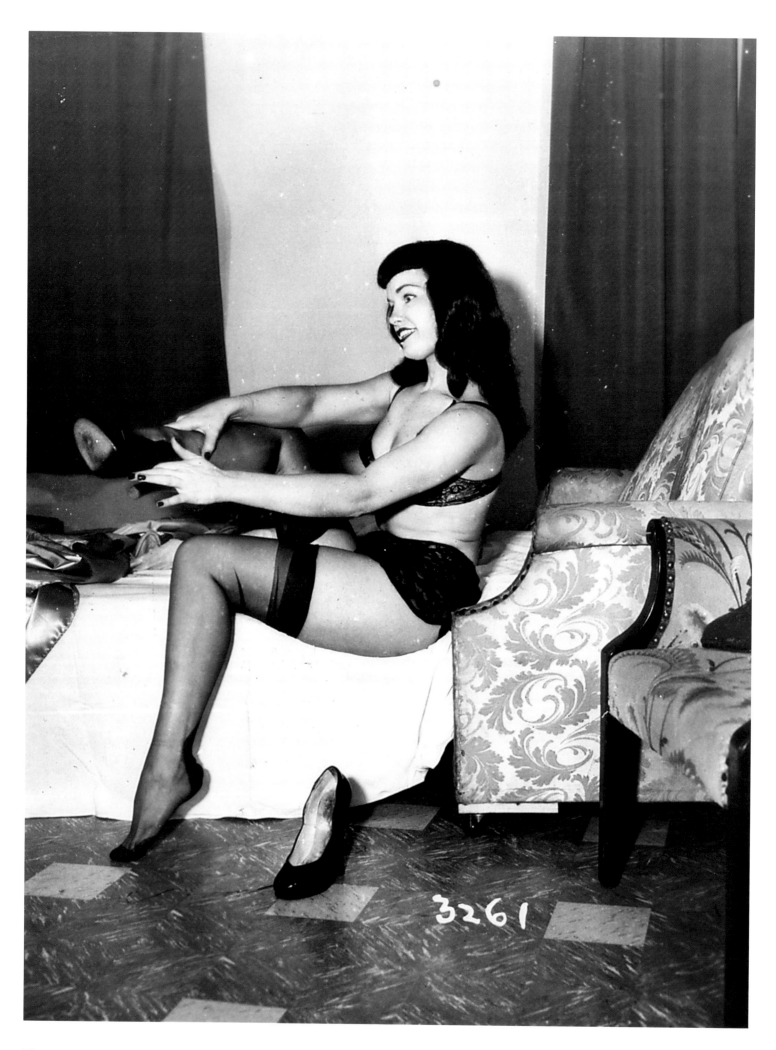

3261

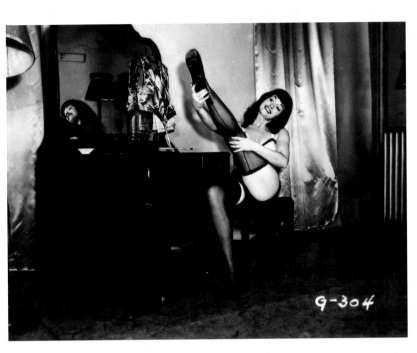

Q-304

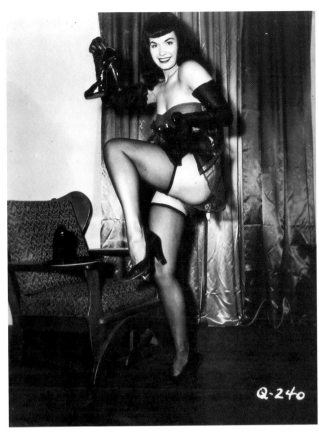

Q-240

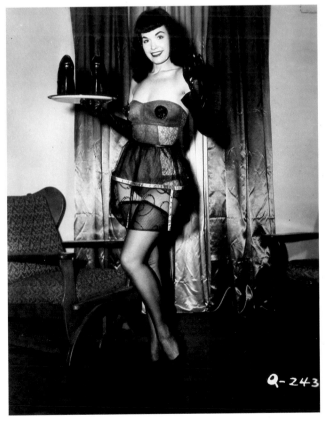

Q-243

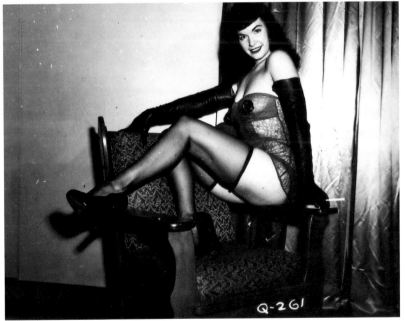

Q-261

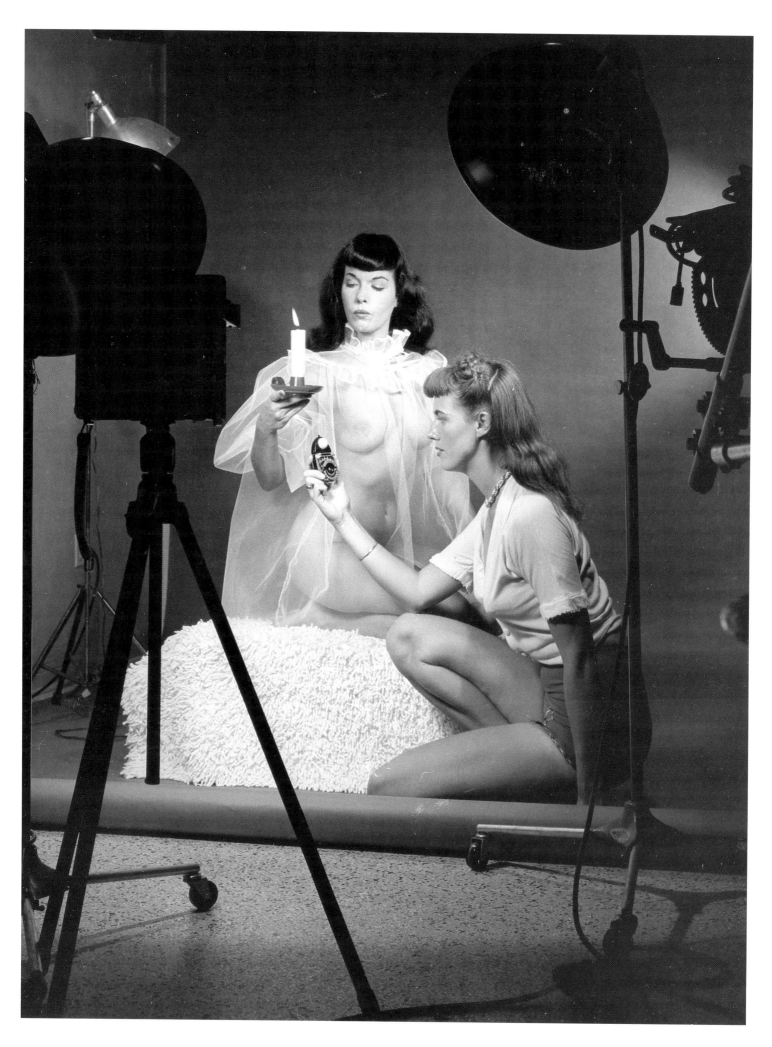

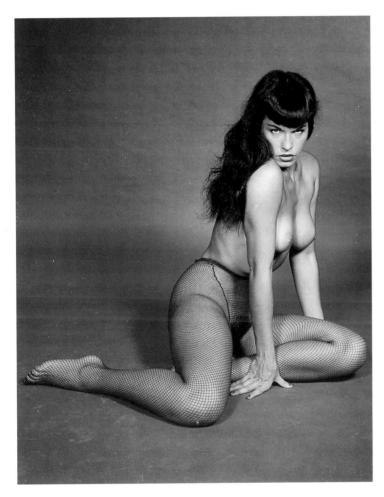
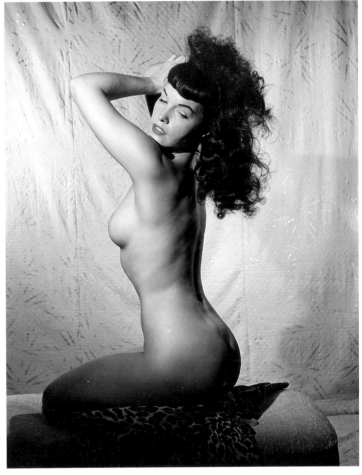

Bunny Yeager

Betty was first photographed by ex-pin-up girl Bunny Yeager in 1955. During the 1950s, Bunny Yeager posed for »Playboy« magazine, among others, before taking up a second career. Her experience on the camera proved very useful in her new profession. She was the most-after photographer of her time.

Bunny Yeager

1955 wurde Betty erstmalig vom Ex-Pin-Up Bunny Yeager fotografiert. Bunny posierte in den 50er Jahren u. a. für das »Playboy« Magazin, bevor Sie ihre zweite Karriere begann. Ihre Erfahrung vor der Kamera konnte ihr hierbei nur nützlich sein. Sie war die gefragteste Fotografin ihrer Zeit.

Bunny Yeager

En 1955 l'ancienne pin-up Bunny Yeager photographie Betty Page pour la première fois. Bunny a posé dans les années 50 pour de nombreux magazines dont «Playboy», avant de se lancer dans une nouvelle carrière. Son expérience de modèle ne pouvait que lui être utile. Elle a été la photographe la plus recherchée de son époque.

Photos: Bunny Yeager, 1955–57

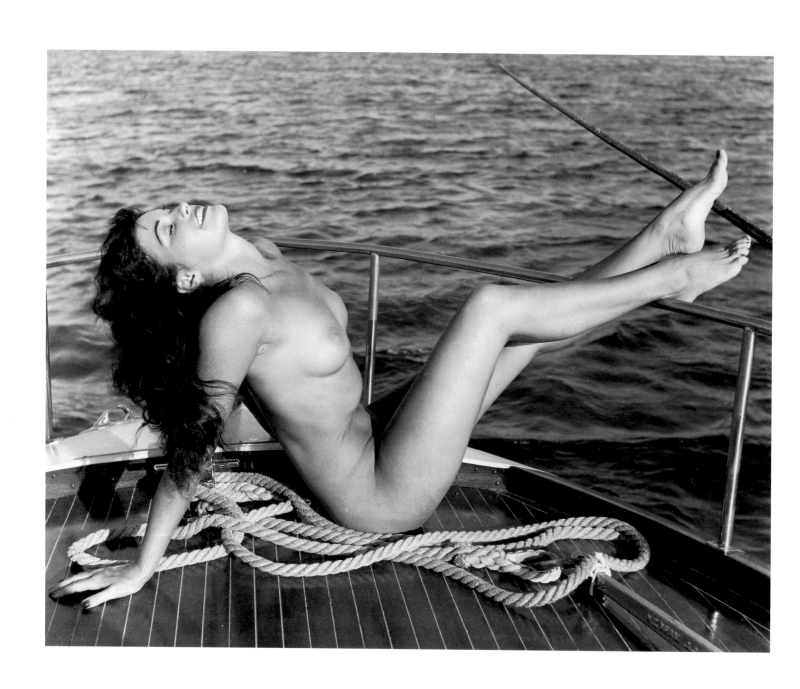

Photos: Bunny Yeager, 1955–57

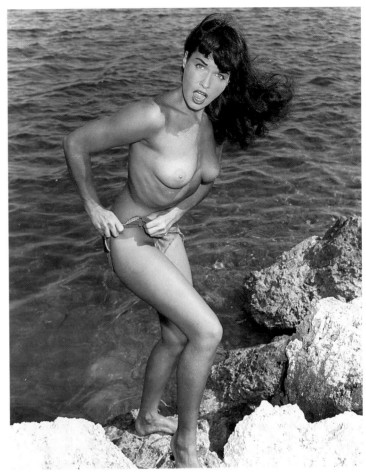

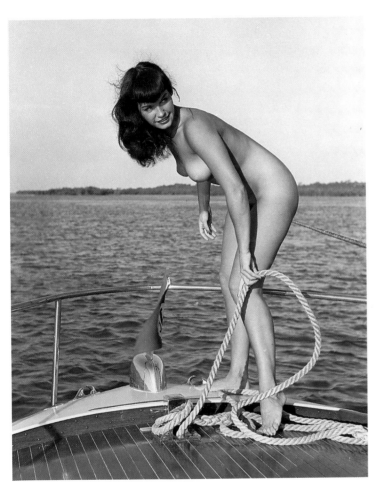

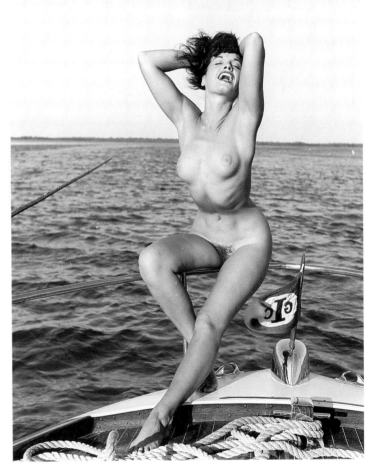

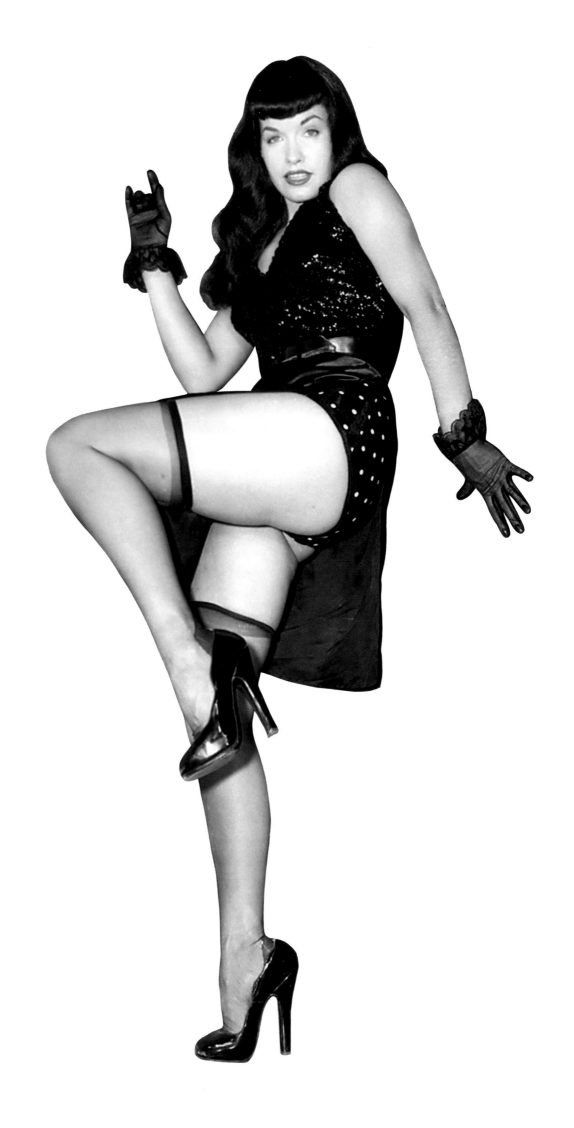

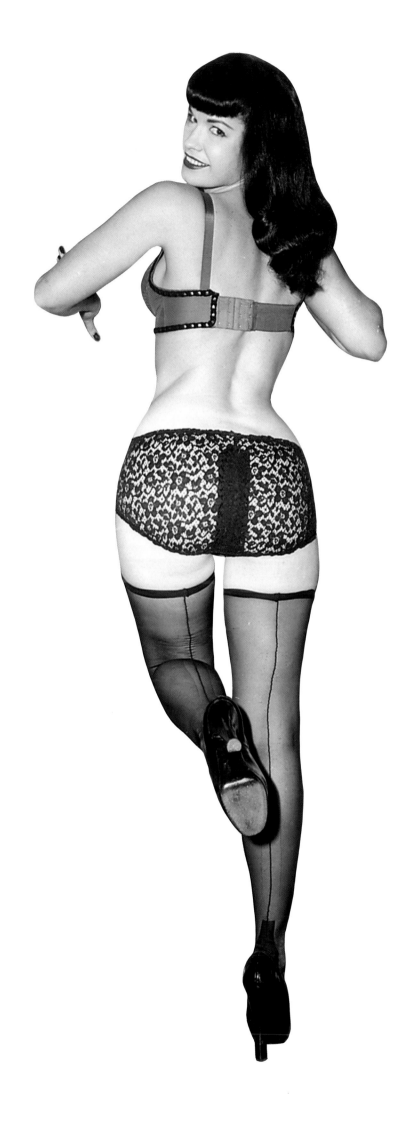

Betty Page (* 1923)

1923 Betty Page is born on April 22nd in Nashville, Tennessee as Bettie Mae Page. Her parents are Edna and Roy Page.

1937/38 Death of her father.

1937–1940 Hume-Fogg High School. After initial difficulties, Betty becomes a model pupil, working for the school newspaper and theatre group. She passes her school-leaving exams with flying colours and says she wants to be a singer with a big orchestra.

up to 1944 Peabody College, studying English with a social sciences subsidiary. Graduates with distinction.

1944 Works for a while as an English teacher. Tries in vain for a Hollywood contract. Moves to San Francisco with her sister.

1947 In San Francisco she meets her first husband and moves to Pittsburgh with him. Their marriage soon founders.

1948–1950 In the late '40s she goes to New York. With Broadway in mind, she takes acting classes. Begins to pose for »camera clubs« and Robert Harrison's »girlie magazines«.

1951 Betty is still one model among many, and her real name does not appear in captions. At the end of the year, probably, she meets Irving Klaw.

1952 Betty is on the cover of Klaw's »Cartoon and Model Parade« No. 53. At a »camera club« shoot in the country, Betty and all involved – including the well-known photographer Weegee – are arrested for causing a public nuisance.

1953 Betty is now Irving Klaw's top model. Photos, films and comic strips featuring her sell fast. »Strip-o-Rama« is premiered at the Rialto Theatre, New York – a burlesque revue in which Betty appears with dancer Lily St. Cyr.

The success of the film (produced by Martin Lewis) impresses Irving Klaw so much that he decides to make full-length colour films too.

1954 Klaw produces »Varietease«, again starring Lily St. Cyr and Betty. In Florida, where Betty often spends holidays with her sister and works for local photographers, she meets Bunny Yeager, an ex-model now embarking on a new career as photographer.

1955 Betty is a »Playboy« centrefold, photographed by Bunny Yeager. Klaw's second film, »Teaserama«, is released. The Senate begins its investigations into Irving Klaw's sales of photographs that could corrupt young people.

1956 Betty still hopes to star on Broadway one day. She acts in drama-school productions and in Long Island summer theatre. At the end of the year she terminates her work with Irving Klaw.

1957 Betty does »camera club« work for a while longer, then leaves New York. Her present whereabouts in America are unknown.

Betty Page (* 1923)

1923 Betty Page wird am 22. April als Bettie Mae Page in Nashville, Tennessee, geboren. Eltern: Edna und Roy Page.

1937/38 Tod des Vaters.

1937–1940 Besuch der Hume-Fogg High School. Nach leichten Anlaufschwierigkeiten entwickelt sich Betty zur Musterschülerin; Mitarbeit bei der Schulzeitung und in der Theatergruppe. Hervorragender Schulabschluß, erklärter Traumberuf: Sängerin in einem großen Orchester.

bis 1944 Besuch des Peabody College. Hauptfach: Englisch; Nebenfach: Sozialwissenschaften. Abschluß mit Auszeichnung.

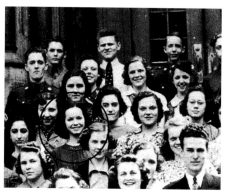

Class photo, Betty at the age of 16, 1939
Klassenfoto, Betty im Alter von 16 Jahren, 1939
Photo de classe, Betty à 16 ans, 1939

1944 Kurzfristige Beschäftigung als Englischlehrerin. Bemüht sich in Hollywood vergeblich um einen Filmvertrag. Zieht mit ihrer Schwester nach San Franzisko.

1947 In San Franzisko lernt Betty ihren ersten Ehemann kennen und zieht mit ihm nach Pittsburgh. Die Ehe scheitert nach kurzer Zeit.

1948–1950 Ende der Vierziger erscheint Betty in New York. Sie will an den Broadway und nimmt Schauspielunterricht. Sie beginnt ihre Arbeit als Model für »Camera Clubs« und Robert Harrisons »Girlie Magazines«.

1951 Betty erscheint noch als ein Model unter vielen, die Bildunterschriften unterschlagen ihren wirklichen Namen. Vermutlich gegen Ende des Jahres wird sie Irving Klaw vorgestellt.

1952 Betty erscheint als Covergirl auf Klaws »Cartoon and Model Parade« No. 53. Bei einer Landpartie mit einem »Camera Club« wird Betty mit allen anderen Beteiligten – unter ihnen der bekannte Fotograf Weegee – wegen Erregung öffentlichen Ärgernisses festgenommen.

1953 Betty ist zu Irving Klaws Top Model avanciert. Fotos, Filme und Comicstrips mit Betty finden reißenden Absatz. Premiere von »Strip-o-Rama« im Rialto Theatre in New York. Eine burleske Nummernrevue, in der Betty an der Seite der Tänzerin Lily St. Cyr auftritt. Der Erfolg des von Martin Lewis produzierten Films beeindruckt

Irving Klaw so sehr, daß er ebenfalls ins Geschäft mit dem abendfüllenden Farbfilm einsteigen will.

1954 Klaws Filmproduktion bringt »Varietease« auf den Markt. Als Hauptdarstellerin engagiert man neben Betty Lily St. Cyr. In Florida, wo sie häufig bei ihrer Schwester Ferien verlebt – und bei dieser Gelegenheit auch als Model für örtliche Fotografen arbeitet –, lernt Betty Bunny Yeager kennen. Yeager war ebenfalls ein Model und steht gerade am Anfang ihrer Karriere als Fotografin.

1955 Betty ist das Centerfold im »Playboy«, fotografiert von Bunny Yeager. »Teaserama«, Klaws zweiter »großer« Film, kommt in die Filmtheater. Beginn der Senatsuntersuchungen gegen Irving Klaw wegen des Verkaufs von jugendgefährdenden Fotos.

1956 Betty hat die Hoffnung, einmal ein Broadway-Star zu werden, immer noch nicht aufgegeben. In Aufführungen ihrer Schauspielschulen und in Sommeraufführungen auf Long Island kann sie Kostproben ihrer Fähigkeiten geben. Ende des Jahres beendet sie ihre Zusammenarbeit mit Irving Klaw.

1957 Betty arbeitet noch eine Zeitlang für die »Camera Clubs«, dann verläßt sie New York und lebt seitdem an einem unbekannten Ort in Amerika.

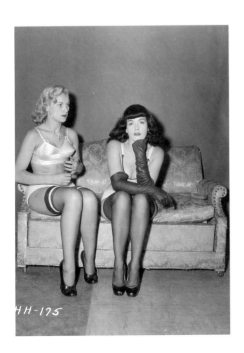

Betty Page (* 1923)

1923 Betty Mae Page naît le 22 avril à Nashville, Tennessee. Elle est la fille d'Edna et de Roy Page.

1937/38 Son père meurt.

1937/40 Fréquente la Hume-Fogg High School et devient une élève modèle. Collabore au journal de l'école et fait partie de la troupe de théâtre. Examen de fin d'études remarquable. Veut devenir chanteuse dans un grand orchestre.

1940/44 Fréquente le Peabody College. Etudie l'anglais et la sociologie. Examen de fin d'études avec mention très bien.

1944 Est professeur d'anglais pendant peu de temps. Essaie d'obtenir un contrat à Hollywood. S'installe à New York avec sa sœur.

1947 A San Francisco, Betty fait la connaissance de Bill qu'elle épouse et suit à Pittsburgh. Ils divorceront peu de temps après.

1948/50 Betty arrive à New York. Elle veut faire carrière à Broadway et prend des cours d'art dramatique. Elle pose pour les «Camera Clubs» et les «Girlie Magazines» de Robert Harrison.

1951 Betty n'est qu'un mannequin parmi tant d'autres, son nom n'est pas mentionné dans les légendes. C'est probablement en fin d'année qu'elle est présentée à Irving Klaw.

1952 Betty est la cover-girl du «Cartoon and Model Parade» n° 53, édité par Klaw. Au cours d'une partie de campagne, Betty est arrêtée avec d'autres participants – parmi lesquels le célèbre photographe Weegee – pour avoir troublé la tranquillité publique.

1953 Betty est maintenant le top model d'Irving Klaw. Les photos, les films et les bandes dessinées où elle apparaît se vendent très bien. Première de

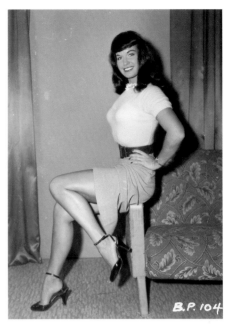

«Strip-O-Rama» au Rialto Theatre de New York. C'est une revue burlesque où Betty entre en scène aux côtés de la danseuse Lily St. Cyr. Le succès du film produit par Martin Lewis impressionne tellement Irving Klaw qu'il décide de produire des films en couleur.

1954 La société cinématographique de Klaw lance «Varietease». Lily St. Cyr en est également la vedette. Betty passe souvent des vacances chez sa sœur en Floride, et pose à l'occasion pour les photographes locaux. Elle fait la connaissance de Bunny Yeager, un ancien mannequin devenue photographe et en début de carrière.

1955 Betty, photographiée par Benny Yeager, est sur le dépliant central de «Playboy». «Teaserama», le second film de Klaw, apparaît sur les écrans. Le sénat commence son enquête sur Irving Klaw qui est accusé de propager un matériel nuisant à la jeunesse.

1956 Betty espère toujours devenir une star du Broadway. On peut la voir dans les pièces des écoles d'art dramatique et dans des mises en scènes estivales à Long Island. En fin d'année, elle cesse de collaborer avec Irving Klaw.

1957 Betty travaille encore un certain temps pour les «Camera Clubs». Ensuite, elle quitte New York pour une destination inconnue.